POP MANGA
DRAWING

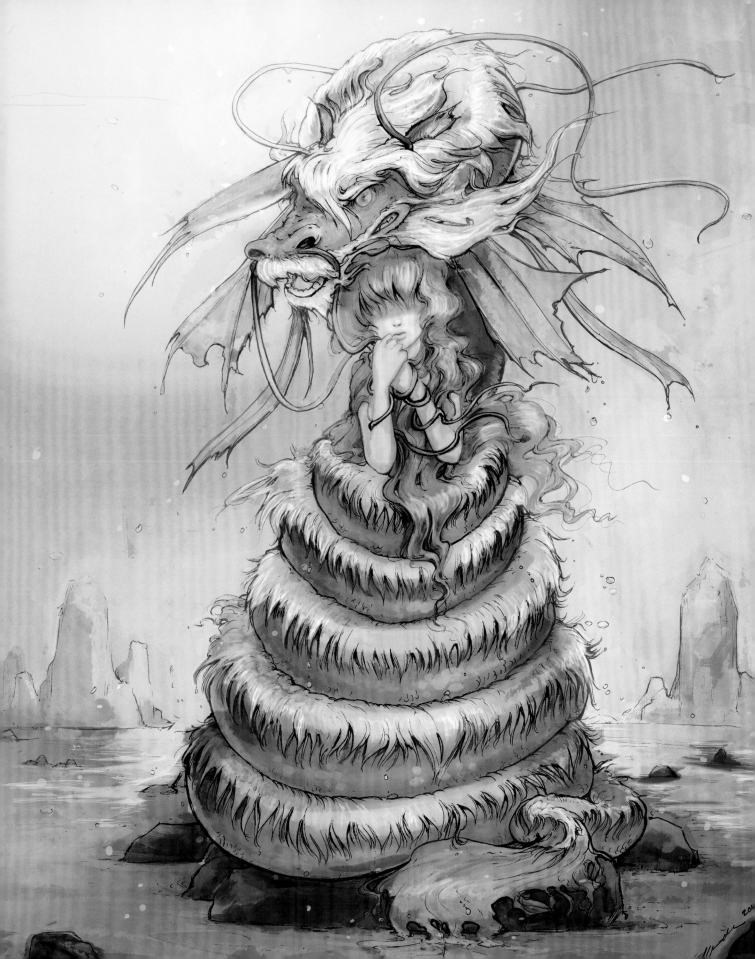

POP MANGA
DRAWING

30 Step-by-Step Lessons for Pencil Drawing in the Pop Surrealism Style

CAMILLA d'ERRICO

WATSON·GUPTILL
CALIFORNIA | NEW YORK

Contents

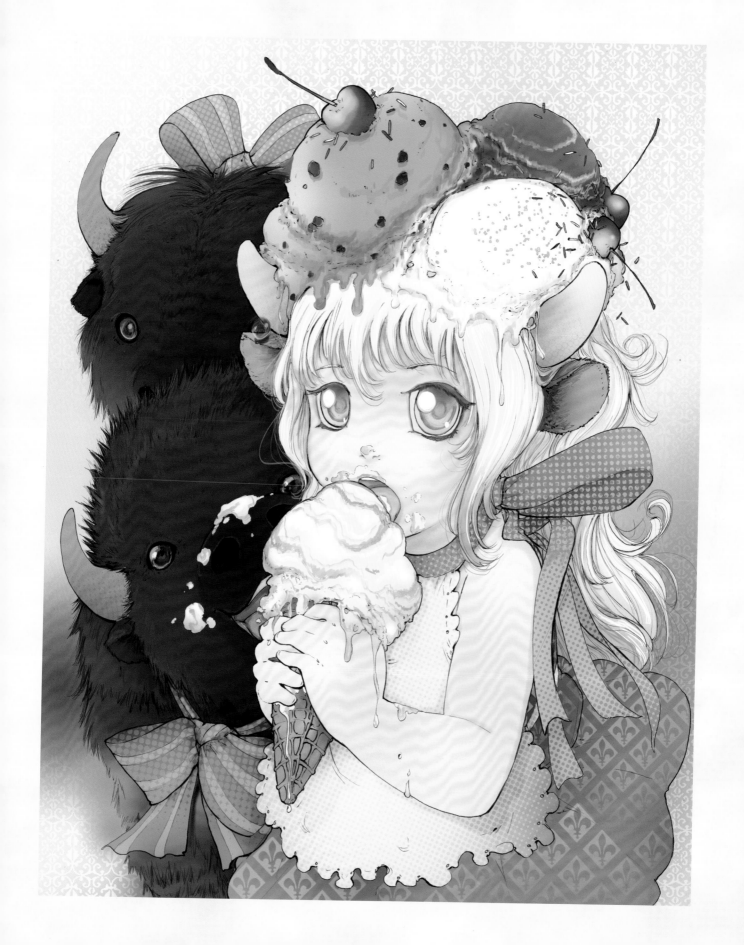

Foreword

I think one very important responsibility that we have as working artists is to reach back, hold out our hands, and help the next generation of artists find their voices. Art is such an incredible tool, mode of expression, and coping mechanism. It is such a beautiful gift to share. One of the things I love about being a millennial creator is the inclusiveness of our art world. In contrast to art generations past that relied heavily on enigmatic hierarchy, we artists who have cut our teeth in the digital age have grown up devoted to the value of connecting with others and being genuine and real. Camilla d'Errico is such a perfect example of these values—giving everything of herself to communicate, connect, and help teach others new ways of harnessing their own voices and refining their skills.

Camilla is one of the most hard-working artists I know, and we share an unquenchable passion for constant creation. In a world with so many forces stacked against artists—and even more stacked against women—Camilla has been able to create her own place in the art world. Sharing your life, your work, and your techniques is hard. It takes a lot of bravery and trust. Camilla has selflessly shared of herself her entire career and has opened the door for so many dreamers along the way. Her sweet, whimsical characters and soft tones lift us up and remind us of the beauty attainable in all of us. Watching her work is mesmerizing. I'm so grateful to experience this time on the planet with her, and to call her my friend on the journey! ♥

—MAB GRAVES

Introduction

Big eyes, shiny hair, cat ears, and a tentacle body . . . wait . . . that can't be right, can it? Well, in the world of Pop Surrealism, that combination is more than okay—it's the norm!

The beautiful thing about art, aside from all the pretty characters and cute animals, is that it allows you to express yourself. Here in the lessons of *Pop Manga Drawing*, you'll go on a great journey and discover new, fun ways to express yourself through drawing.

Sometimes you may need a little boost on the path to creativity. That's where this book comes in. I know what it's like when you're just starting to learn how to draw. But I've also been drawing for a loooooooooong time, and I'm *still* learning. Lots of what you will see in the pages ahead are lessons that I had to teach myself. You'll find tips based on insights gained over the years. These include ways to push yourself creatively and (most importantly) ways to have fun while learning a new art style.

I've created a series of step-by-step lessons that will help you develop your Pop Surrealism style. Lessons go from beginner to intermediate to master class, so it's important to start at the beginning and work your way up to more difficult and challenging drawings. There will be lessons on how to draw fuzzy bees, how to draw a girl with cat ears, how to draw a vampire boy with a wild surreal twist, and so much more.

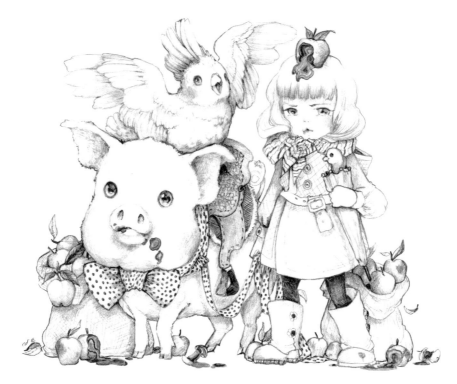

POP MANGA: WHAT IS IT?

To define the ultrafun style of Pop Manga, let's start with the "manga" part. Simply put, *manga* is what the Japanese call comic books. Over the years, manga evolved from woodcut drawings into a nationwide craze of serialized stories that have defined a culture throughout the world. Typically, manga is drawn in black and white. *Mangakas* (manga artists) draw the characters with big heads and eyes, eyes so big they defy physics. Their eyes aren't just the windows to the soul . . . they are the French doors to the soul!

Personally, I love manga not only for its round-cheeked, cherublike, school uniform–wearing characters, but also for their fantastical hairstyles and crazy expressions. Manga jumps from superserious to cartoony shenanigans as quickly as you can snap your fingers. There are no boundaries with manga.

Now it's time to explain the "pop" in Pop Manga! Hold on to your bootstraps, because the "pop" is what takes manga from cute to surreal. Pop is short for Pop Surrealism. That's a contemporary style of North American art that developed in Los Angeles in 1970, as dark cartoon punk Low Brow art evolved into the whimsical, colorful, and exciting Pop Surrealism movement that blurs the lines between Low Brow and High Brow artwork.

Think of Pop Surrealism as a blending of pop culture and the work of Salvador Dalí! It is a style where whales are part bumblebee, mermaids have angel wings, and girls and boys walk upside down in a Willy Wonka–esque fairground.

When you mix Pop Surrealism and manga, you get my art style—the one that I use to illustrate manga like my Tanpopo series, and even webtoons like my Davinchibi comic! I break the rules of logic and physics like a proper villain. Ha-ha, I'm just kidding. I'm not a villain, more like the Mad Hatter. What I like about Pop Manga is that I can blend two different styles and cultures. It's art fusion, baby!

Now it's your turn to try on my creative hat and see if it fits. If you're ready to bend reality, turn the natural world upside down, and learn how to use graphite to do so, let's begin! Get your pencils sharpened and step into the world of *Pop Manga Drawing*.

Hello there, my lovelies! My name is Matita, but you can call me Mati! I'm Inku's way cuter counterpart, he's my cousin twice removed on our brother's mother's grandpappy's side! He helped you in *Pop Manga*, and now it's my turn to take the reins. So, get ready for some fun, babies!

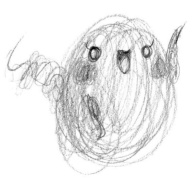

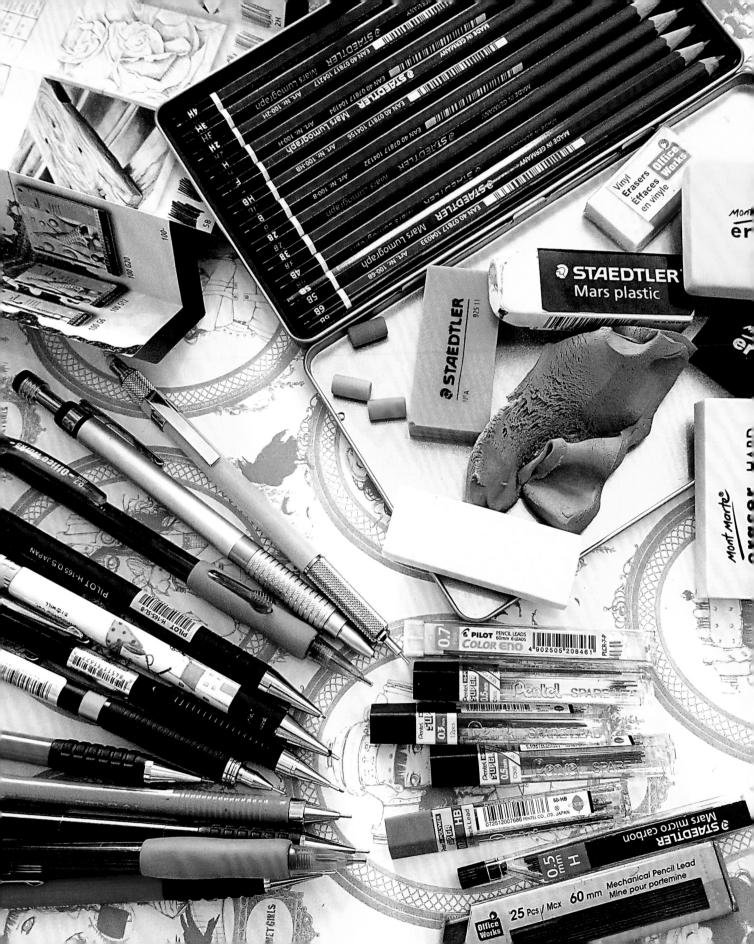

Tools to Use

For the lessons in this book, I'll focus on showing you how to draw manga in a unique Pop Surrealist style with graphite pencils. Pencils are one of the first tools I used for drawing, and I'll wager that's the same for many of you! There are all kinds of pencils, so I'll do my best to guide you through what I use to create my graphite drawings. You can draw with pretty much anything. But for this particular style of Pop Manga drawing, here are my recommendations for graphite pencils. I'll break down the kinds of pencils and the types of lead you'll have to work with and how to use them.

Matita means pencil in Italian. Isn't that just the cutest, just like me?

MECHANICAL PENCILS VERSUS LEAD PENCILS

Personally, I like to use mechanical pencils. It's nice to have a tool that I don't have to sharpen. I just go *click, click, click*, and fresh new lead appears.

However, there are some cons. Mechanical pencil lead is fragile. If you drop your pencil, it might shatter the graphite inside. It's also hard to tell if you are about to run out of lead. (I recommend always carrying around an extra set of leads, if possible.) Each mechanical pencil comes with its own unique weight, thickness, length, and style. What works for some may not work for others, but I love the variety! No two hands were made the same, so try out several pencils to find the one that both suits your personality and fits best in your hand.

The so-called "lead" in pencils is actually graphite. Once upon a time, pencils were actually lead filled. But in the 1500s, a large deposit of nontoxic graphite was discovered in England, and eventually graphite replaced lead in pencils. Today, people use the terms "lead" and "graphite" interchangeably. I use the term "lead pencil" to refer to a wooden pencil, as opposed to a mechanical one.

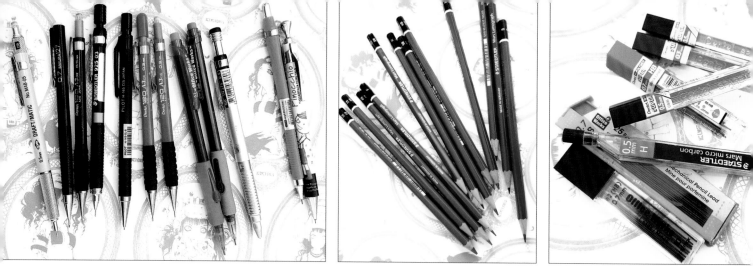

Lead pencils are traditional and sturdy. You can regulate the thickness of the tip much more easily with a lead pencil. Additionally, these pencils come in a wide range of lead types, which are explained ahead. Having a variety of lead options is fantastic, as it allows you to open up creatively.

However, you'll need a good sharpener on hand to keep your pencil tip sharp. They're also super messy, as bits of pencil flake off with each sharpening. Additionally, they tend to be costlier to replace.

Different Lead Types

Mechanical pencils are classified by the thickness of their leads: 0.3 mm (the thinnest), 0.5 mm, 0.7 mm, and even 0.9 mm (the thickest). The thicker your lead, the thicker your lines. It's good to use a variety of thicknesses. You can switch between different pencils to get the details you want.

Lead pencils come in a huge assortment based not only on thickness, but also on the softness and hardness of their graphite. What does that mean to you, the artist? It's simple. The harder your lead, the lighter the mark you can make with it. The softer it is, the darker your mark. Hard leads are available in increasing hardness from H to 10H. Soft leads increase in softness from B to 10B. Pencils graded F and HB are in the middle of the spectrum between H and B, with F being slightly harder and HB being slightly softer. You see what I mean when I say they come in a range!

See how many different line thicknesses you can spot in me! Changing your line thickness makes for some great detailing!!

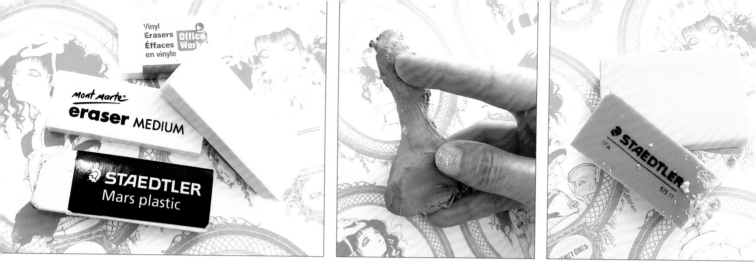

ERASERS GALORE

One of the best things about using pencils to draw with is that you can erase your mistakes. As you might guess, there are all kinds of erasers. I won't get into all the different ones available. Instead, I'll focus on the ones that I use and add a couple of other suggestions.

White Erasers

The best eraser to use is a white eraser. It's my favorite. It works super well, and picks up tons of graphite with little pressure. The more pressure you have to use when erasing, the greater chance you have of damaging your paper. Keep a spare piece of paper to the side so you can wipe off your eraser as you work. That way you won't rub and smudge graphite from your eraser back onto your drawing.

Mechanical Pencil Erasers

Mechanical pencil erasers are great for getting into the nooks and crannies of your art. They're precision tools, so it's good to have them on hand when tackling areas that a big, wide eraser can't reach.

Kneaded Rubber Eraser

This type of eraser is professional grade and lasts a long time. Its design allows for self-cleaning. You simply stretch it out and pull it back together—like pizza dough. It's the best eraser to use if you don't want eraser bits going all over the place. It's also great because you can shape and mold it into little points that can help you get into tricky areas.

Gum Eraser

This super messy eraser leaves behind crumbs like shredded cheese when you use it. That said, it's perfect for use on delicate paper. You need very little pressure when using this one. It's designed to crumble, so the more pressure you use the faster it falls apart. That feature should keep you from pressing too hard and possibly creasing your paper.

PAPER

The surface you draw on can influence what your final drawing looks like. Because there are so many paper options, I want to simplify things by sharing what I use.

But first, you need to know some technical terms that will help you pick out the paper that's right for you. The *weight/stock* of a paper refers to its thickness. Paper weights are referred to in pounds (lb.) and grams per square meters (gsm). The US system weighs paper in pounds, while the metric system measures the weight in grams per square meters.

A lightweight paper might be 20 lb. In contrast, a thicker cardstock paper can be up to 150 lb. To give you a more specific example, standard home printer paper (bond paper) is really lightweight, usually 20 lb. Poster board paper is 110 lb.

When you draw, you'll want to use a heavier paper. That way there's less chance of ripping the paper or creasing it, not to mention poking holes in it! I recommend using around 80 lb. paper.

Texture/tooth refers to the smoothness or roughness of paper. The paper shown below on the left is an example of a textured fine art paper, while the one on the right is an untextured paper. Some papers have certain textures that make drawing with graphite very difficult. If paper is too glossy, then your graphite won't stick to it. On the opposite end of the spectrum, heavily textured papers can make drawing hard because of all the ridges on the surface. Some papers (such as Yupo brand) feel almost like butter, so soft and creamy. (It's true! It's like touching a baby unicorn!) The softness of the less textured papers makes it easy for the graphite to stick to it, but erasing on these kinds of paper can be tricky since they are more delicate, so be gentle when working with them. My favorite paper is an in-betweeen of textured and smooth. I like to use a bright white paper that has the texture of home printer paper but is thicker, in the range of 50 lbs. or 80 lbs. (so it's not as fragile).

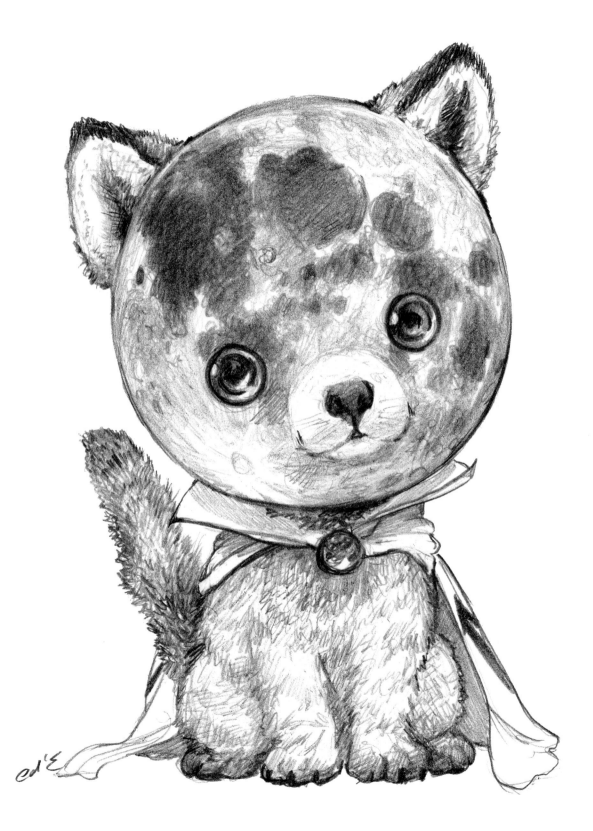

Techniques

Using graphite pencils requires you to learn some of the techniques associated with this wonderful medium. Let's explore different ways of rendering your drawings. First, I'll show you to how to add dimension via shading techniques. (These are my favorite ways to shade!)

CROSS-HATCHING

Cross-hatching is a shading technique that involves drawing layers of diagonal lines over top of each other. The result looks like a mesh pattern, and you can use that for shading as well as for adding texture to drawings.

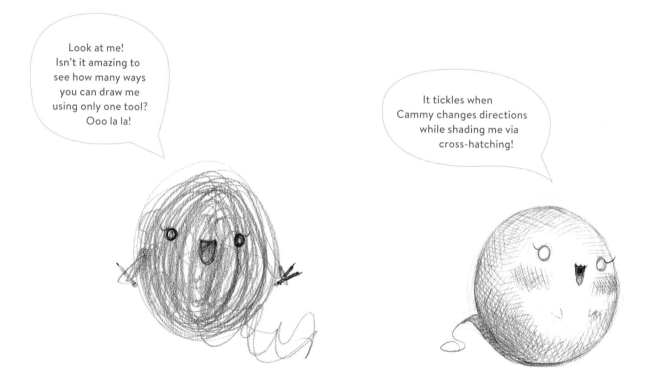

SMOOTH BLENDING

You can do wonderful shading effects with a pencil by gently rubbing your pencil against the paper with even pressure. You can use a circular motion or lines in one direction, then turn the paper around and repeat that same motion. Doing so gives you a really nice result that allows you to control the darkness levels. Just be careful not to use this technique on textured paper, because the texture will show up in your shading.

SMUDGING

Use a stump or a smudge stick, available at your local art supply store, or your finger, for this very distinct way of shading. You press lightly and move the stick or your finger around until the lines blur. This technique allows you to get a very smooth look, but it can get messy, so have a rag on hand for clean up!

This type of shading makes me look so three-dimensional! I hope that extra dimension gets my good side!

Smudge carefully, baby!

Warm-Up Exercise:
FIND THE IMAGE IN THE LINES

All right peeps, time to get your creative juices flowing! Here's a fun challenge to get your brain firing and your wrist warmed up.

STEP 1: Take a blank piece of paper and a pencil. Now, without thinking about what you're doing, doodle like crazy using one continuous line. Just start drawing a line, and swirl it around the page.

STEP 2: Once you create your doodle, take a look at what you drew and imagine the shapes hidden inside it. Flex your creative muscles, and concentrate on the lines until you can imagine something within them. It's kind of like seeing shapes in clouds! Fill those shapes in with your pencil. Do this a couple of times and see what you can come up with!

If you are with friends, it's fun to doodle, and then pass your sheet to someone else to see what crazy creature they imagine hiding in your doodle! Try envisioning a different image from my example doodle and show me what you got!

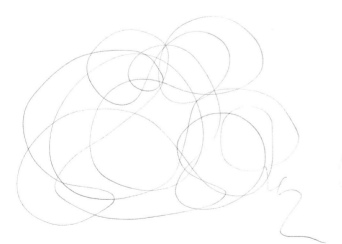

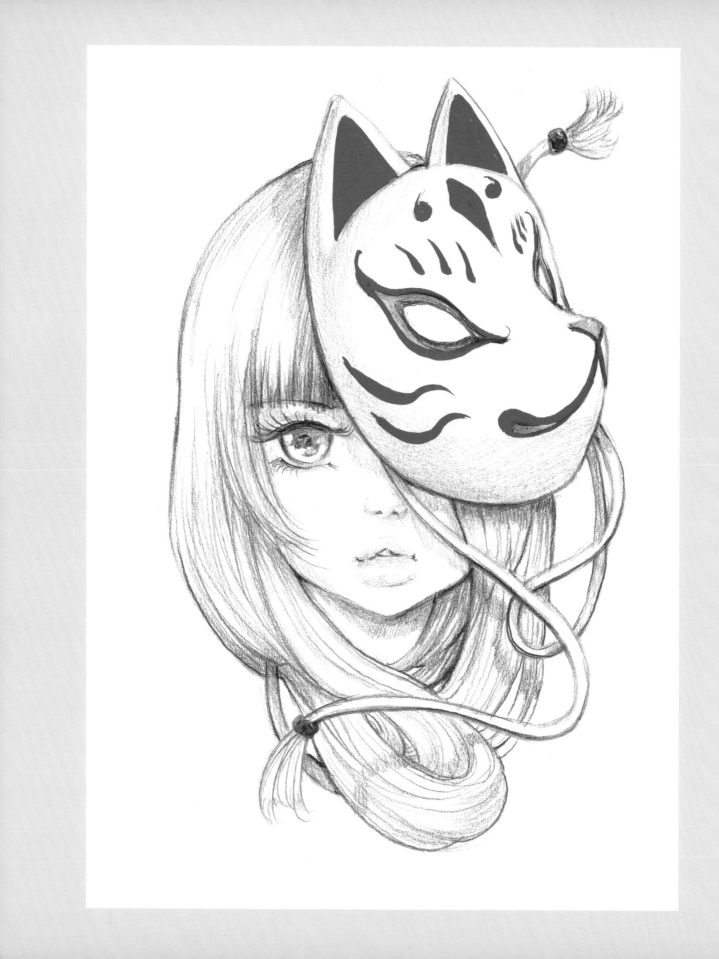

ONE

BEGINNER LESSONS

Let's start with some fun, simpler lessons to kick things off. In this section, I'll teach you how to draw a variety of images that will help ease you into the world of Pop Surrealism. Learn the basics like how to draw different kinds of characters and hair styles, and begin learning about textures and facial expressions as well as how to put together elements in your image that speak to the soul of both Manga and Pop Surrealism. These may seem complicated, but when you break down the elements one by one and weave them into an image, you'll see that what seems complex is really just a little puzzle put together. We'll start small and work our way up! Like the saying goes, "Learn to walk before you run."

Great Hair Day

One of the fun things about Pop Surrealism is that it doesn't have to make sense! I'm not talking about wearing-your-underwear-on-the-outside-of-your-pants levels of weird, though. I'm thinking more along the lines of a girl whose hair is so long and so thick that she lives in it! So, let's break the laws of normalcy and jump into some serious hair envy!

Oh boy! Here we go! Time to draw! I'll be right here with ya to drop in some pro tips while Cammy teaches you step by step how to draw. Let's do it! Drawing is all about shapes, so start with basic shapes like circles and triangles to determine the elements in your drawing.

STEP 1: The drawing for this lesson may end up a little different than you might expect. You are only going to show the top half of the girl's face—from the nose up! So, first, use an HB pencil to draw a circle with crosshairs indicating the direction your character is facing, and include an oval area for her hair. It kind of looks like a sunny-side-up egg! This part of the drawing is called your *underdrawing*. It's okay to be messy with it since it's just an outline for your drawing that you'll end up erasing!

STEP 2: Draw circles for her eyes (and add eyebrows) on the crosshair line. The crosshair line helps you place the eyes level with each other. When drawing just eyes, you can use the eyebrows to convey emotion!

STEP 3: Now it's time to lightly sketch in the hair. I start with the bangs, and then move to the contour of the head. When drawing this step, think of it like a big bowl of spaghetti. Draw squiggly lines! Remember to keep things nice and loose in the early stages.

STEP 4: Start refining your drawing. Erase some of the underdrawing. Then with an H or 2H hard lead pencil, add a few more ripples of hair in front of her face. You can leave out the nose if you want or draw it in, it's up to you!

STEP 5: Switch to a darker lead (2B or 3B), and darken some of your contour lines to help provide definition and to create some order to the madness! I press down and don't lift my pencil off the paper until I've completed the lines. Be confident with your pencils! Swirl and twirl like you're gliding on ice!

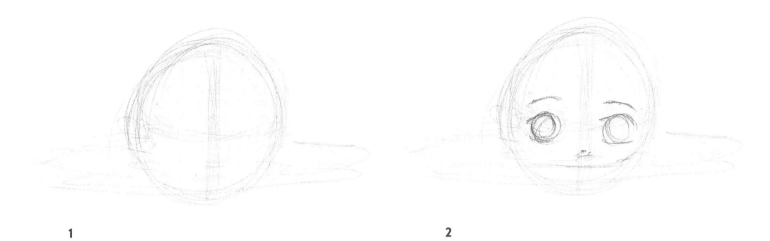

1

2

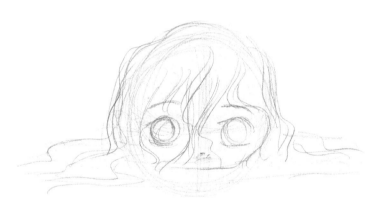

3

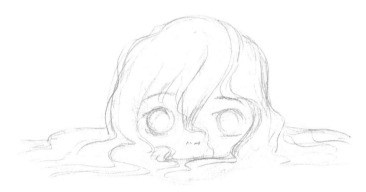

4

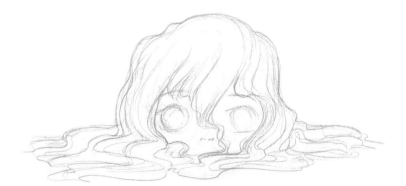

5

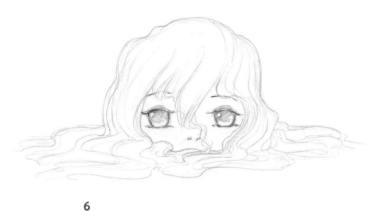

6

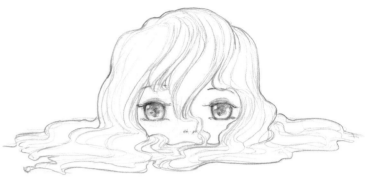

7

8

9

STEP 6: Take a break from the hair and fill in the eyes. Start by drawing a small circle at the top left corner of the eye. Darken the eyelashes as well as the iris. Then, shade the eye in by adding graphite at the top and moving down. Make sure to change your pressure from firmer to lighter as you move down the eye, doing so will create an ombre effect. *Ombre*, for those who don't know, is when the color in an object shifts from a light color to a darker color. It's a popular hair coloring effect that I love!

STEP 7: Use a softer lead, such as 2B or 3B, to draw darker lines and to start defining her hair. Use the same pencil to finish the eye by drawing in pupils. I like to use medium-firm pressure on a first pass, and then follow up with a darker line.

STEP 8: For this step, switch back to a lighter lead, a 2H or 3H and shade parts of the hair. I like to shade in the parts that are the opposite of the highlights which are at the top of the object to create shadowed areas. Remember the shading is where the shadows are! The shadows you add now should follow the dips and valleys in her hair.

STEP 9: Let's get bold! Switch to a darker lead pencil (4B) and add in darker, deeper shadows. I like to draw those in with super fast strokes! You can be a speed demon like me, or take your time. You don't have to fill in the hair all the way, of course. You can leave it pure white if you want! I like to include a touch of definition so the hair looks shiny.

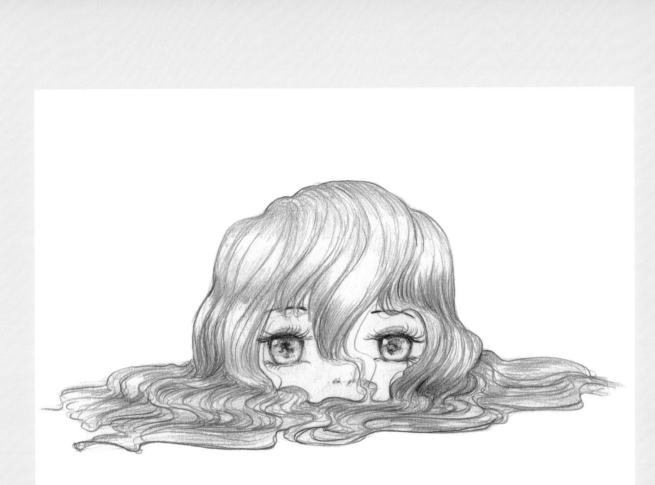

FINAL

FINISHING UP: Finish your drawing by adding in details for the eyes, a few more shadows here and there, and a bit more definition to the hair. Think of these details as the final polishing stage. And there you have it! A girl submerged in her own hair, Pop Manga Surrealist–style!

SMUDGE PROTECTOR!

Using graphite and pencils means one thing: smudging!!! Forgetting to lift your hand as you pass along the paper can result in smudges. However, there are a couple of ways to prevent smudging: (1) Use a stick as a barrier. Rest your hand on the stick as you draw, thus preventing contact between your hand and the paper. (2) Wear a fingerless glove. I've been known to cut the tips off cheap winter gloves and put them on while drawing. I've also repurposed old socks that have holes in them! Recycle, baby! The cotton won't smudge the graphite as much as the oils in your hand (though it will still smear if you're using very soft leads).

Tina Tentacles

Who likes mer-peeps? I know I do! I love all sea creatures, especially the octopus. Octopuses are so squirmy and smart, not to mention adaptable. That's why I love the idea of combining a manga girl and an octopus. That's one of the signature elements of my style, blending tentacles with humans. So, let's make an Octo-girl!

What's a *light source*? Well silly, that's industry talk for where light is shining down from! Imagine what time of day it is before you add shadows to your character. If it's high noon, then shadows are directly underneath objects, and if it's late afternoon, then shadows will show up on an angle, for example.

STEP 1: Begin by drawing a circle to represent the girl's head. You'll move from the head to the neck, and then to the tentacles. You can play around with different variations of the lower body, but make sure that the tentacles appear and make sure they overlap each other. Doing so shows movement in your drawing.

STEP 2: Using light strokes, add in details to the face and tentacles. Octopus tentacles have suction cups, so I like to add them here. Focus on the outline of the girl's hair and her expression. I'm going to make her look a little surly. I do so by furrowing her eyebrows, which is achieved by drawing them angled downward at the center of her face and half closing her eyes.

STEP 3: Using one of your erasers, remove the underdrawing as best you can. It's okay to erase part of the character and then redraw if you need to. You're at the perfect stage to get the character to look how you want it to look. I decided to have her tongue sticking out.

STEP 4: Now that your drawing is free of extra lines, it's time to refine. Start with the girl's hair and the outline of the tentacles. I like to use more pressure and a darker lead (3B) to achieve some nice definition. Work from the hair down to the chin.

STEP 5: For this step, it's important to finalize your *contours*—the outer lines of your drawing. I also like to add more hair by gently stroking my pencil quickly over and over again in the tentacles and hair area to create more dimension in the strands.

STEP 6: Now focus on the facial details! I always start with the eyes and their surrounding features. I like to draw the eyebrows as a starting point! With light strokes, draw the top of the eye and the eyelid. Then draw in the iris as if it were a half circle. Use harder pressure to achieve the dark lines and lighter pressure for thinner, lighter lines.

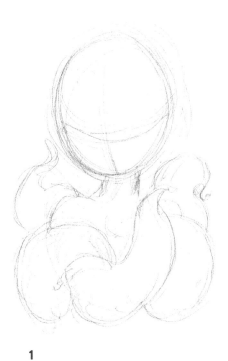

1

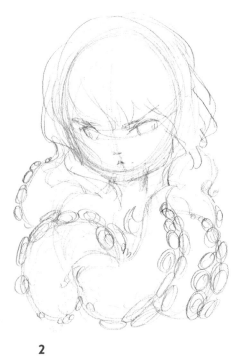

2

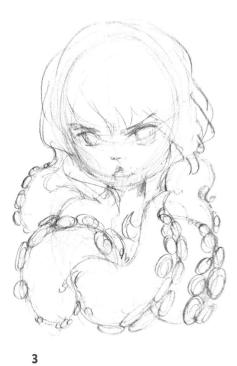

3

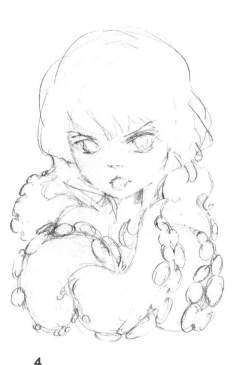

4

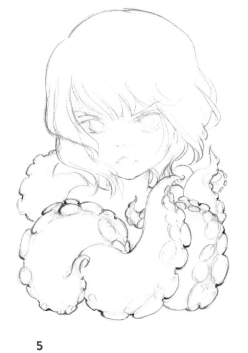

5

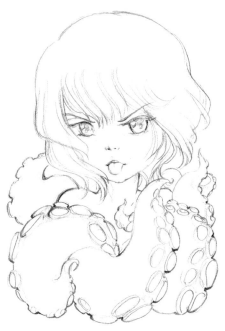

6

7

8

STEP 7: Time to shade! Start with a light lead (2H) and angle your pencil low to the paper so that you can get a flatter mark. The more you tilt the pencil vertically, the sharper your line will be! Apply some pressure to solidify parts of your outline. Choose your light source and begin to add shadows.

STEP 8: The more shadows you have, the more dynamic your image will be! Add some textural variety to your drawing by using different strokes and by blending. The shading of the hair should follow the contour of the hair to make it looks realistic. The tentacles don't have a hairlike texture though, so try blending and softening your shading on them to look smoother. They look spongy now, don't they?

FINISHING UP: (Opposite page) For this final step, darken details, add more shading, and clean up your lines. Deepen the contrast in the eyes by adding darker pupils and shade areas to make them look shiny. Voilà! You've got yourself a sassy octo-girl!

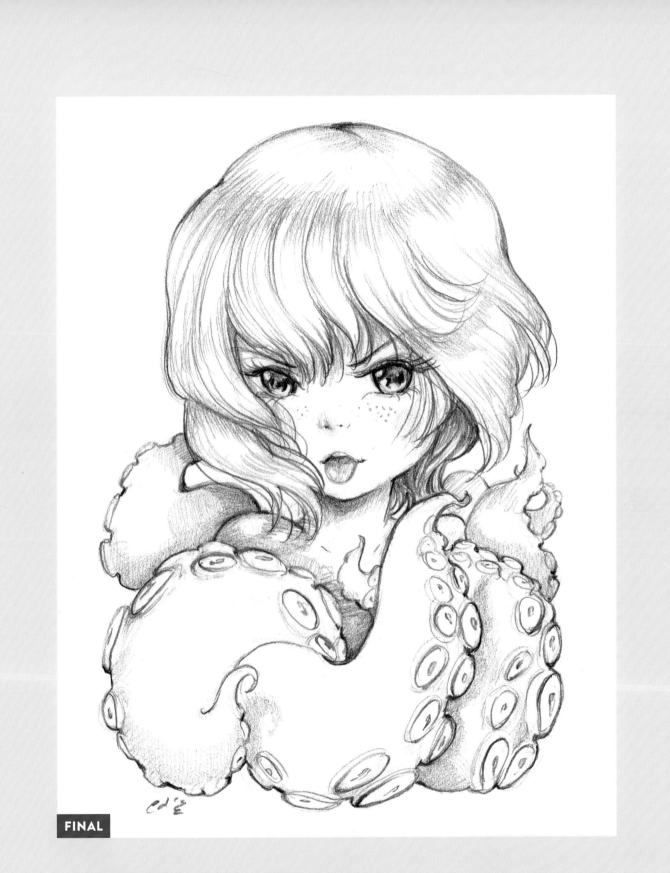

FINAL

Getting Inspired and Overcoming Artistic Blocks

Looking at a blank piece of paper can be very intimidating. It's so stark and so blank, but it's also full of so many possibilities! You need both confidence to put a mark on the paper and the fortitude to finish your drawing once you get started.

Ideas happen when you least expect them, and, if you don't keep track of them, they can often abandon you as well. Sometimes when I'm running, something triggers an idea in my head. I immediately stop what I'm doing and write it down or sketch it out.

The methods for overcoming an artistic block are unique to each individual. We artists put a lot of pressure on ourselves to be creative and to produce ideas, and when there aren't any ideas, our minds can panic and set up blocks. Ahhhh, the many hours I've spent staring angrily at an empty sketchbook or madly jotting down any idea that came to me, only to trash them seconds later!

To deal with artistic blocks, first step back and take a break. Go for a run or do some other physical activity to get your endorphins going! A happy brain is a productive brain. Changing your scenery is also good. It helps you focus on things outside yourself. Trust your instincts. You are the artist, and your creativity is your tool to wield! Just remember to believe in yourself and try not to be too critical of yourself, okay? If you set your mind to it, you can move mountains, and tame your own art dragons!

Fluffy Fuzzbutts

Let's try drawing a fuzzy bee! For this lesson, I'll show you how to "shape" an object made entirely of fuzz. Texture is a really fun element to add to your artwork, so have fun with trying various kinds of textures!

STEP 1: Using a hard lead pencil like a 2H, create your initial guideline shape. Don't worry about making it perfect. Establish the bee's girth and the various sections of its fuzz.

STEP 2: With a soft lead, 0.7 mm mechanical pencil, or a 3B lead pencil draw the solid parts of the bee, the face, the legs, the wings, and so on. Avoid drawing too close to the places where the fur covers those points (like the top of its head or the back of its stinger). Leave uneven, jagged edges to show where you will draw the fur later.

STEP 3: Erase your underdrawing lines carefully. I like to leave some bits of the lines intact so that I can see where the different colored sections of the bee's stripes will go. Now is also a good time to draw the wings and to finalize the face by shading the head. You can use a 0.5 mm mechanical pencil for both features.

STEP 4: Bring on the fluff! With a soft lead pencil (3B), draw in the fur one layer at a time. Start with the top layers and let your pencil line follow the curve of the bee's body. Think of the little guy as a balloon with fur. Curve your lines so that it looks like the fur sticks straight up at all angles. I'll often turn my paper as I draw. That way my lines look more natural, and I'm not forced to bend my wrist at a weird angle. Fuzz like you see here looks best when made with short, quick little marks.

STEP 5: Fill in the black fluff! The trick here is to use lots of tiny lines, turning the paper as you go. Start at the front of the bee and work your way back. Leave a little room between each layer of fluff as you work so the fuzz isn't too compact (it'll take a few layers to fill everything in). When drawing fluff, quickly flick your pencil down and then up, and repeat for each stroke.

Draw all of your initial lines with simple bloblike shapes using your hard lead (2H) or press lightly to achieve pale lines.

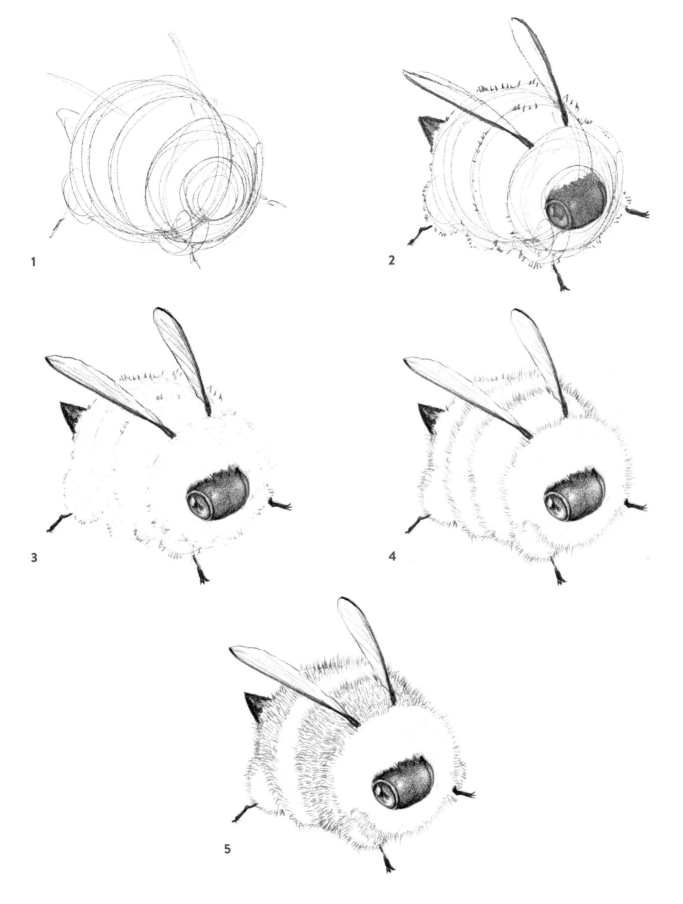

1

2

3

4

5

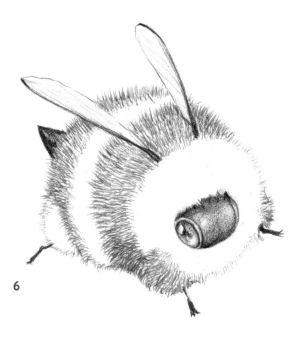

6

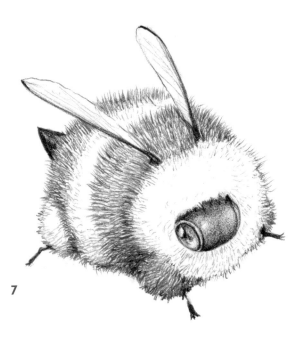

7

STEP 6: Switch to a harder lead (3H) and fill in the lines. It's okay to go over the marks you just made with another round of quick lines. The more layers you include, the darker the fur appears. White fur requires a lot less drawing than dark fur. Add some quick short strokes at the top and near the bottom to show dimension. It can also be fun to include some shadows. Just add the fur to the shadowy areas. Use pressure to darken your lines.

STEP 7: Go over the darker areas of fuzz and add more details. Add shadows to the underside.

HOBBY OR PRO

Doing art as a hobby is making art that's all for you, baby! You don't have to worry about meeting deadlines or creating art for someone else. There is a freedom to creating art whenever you want and to not feeling the pressure of performing well. The downside is that you have to put your other work first. Bills need to get paid and life needs to move forward, so you may not always have time for your art when it's a hobby. But if you manage your time and give yourself time to create art, then being a hobbyist artist is a truly wonderful way to express your creative side.

Whether you do art for yourself or as a career, always remember that you are creating from your soul.

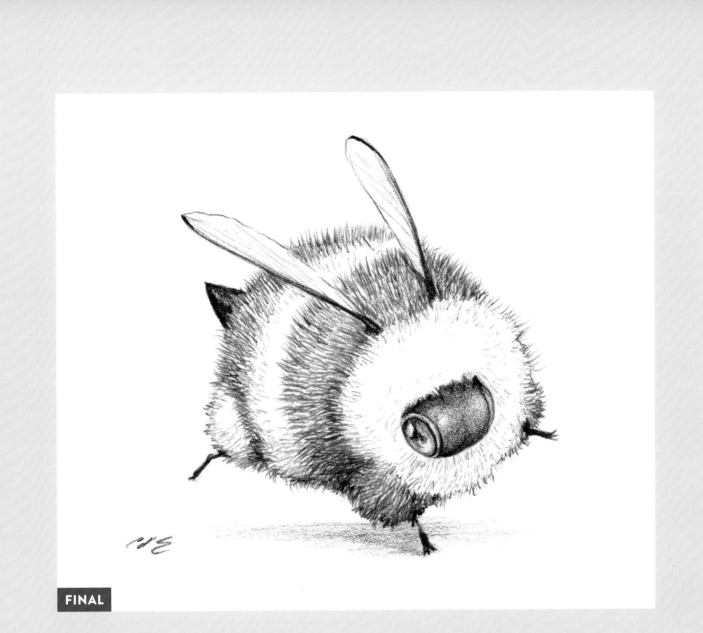

FINISHING UP: And voilà! You have a fluffy bee.
Try using this technique on other creatures and see
how fluffy you can make a doggy or a kitten!

Moonbeam and Me

One of the cutest manga styles is the chibi style! *Chibi* means "little" in Japanese. When applied to manga, it means drawing little versions of your characters. The chibi body is teeny-tiny with itty-bitty hands! Chibis are so cute, I can't handle them! So, let's draw one in the Pop Surrealist style by turning the moon into a sidekick for a little vampire!

STEP 1: You draw chibis in much the same way that you draw regular-size characters. Always start with the head. Draw it as a circle and make the body more of a teardrop shape. Include little sticklike limbs. You can use any kind of pencil for this stage, I like to use a harder lead like an HB. For the ghost, draw a half-moon shape.

STEP 2: Time to add some cuteness! Chibi faces are more squished than normal ones, with huge eyes and no noses. Since they typically have exaggerated expressions, you can have fun selecting what your characters will look like!

STEP 3: Add some vampiric features like a cape and fangs and little skulls to her ensemble. Keep your line work pale so that you can fully define these elements in the next step.

STEP 4: Darken your character's outline. I like to use a thicker mechanical pencil such as a 0.7 mm or a 3B or 4B graphite pencil.

Wait a minute, big expressions and no nose . . . does that mean I've been a chibi this whole time? Mind blown!

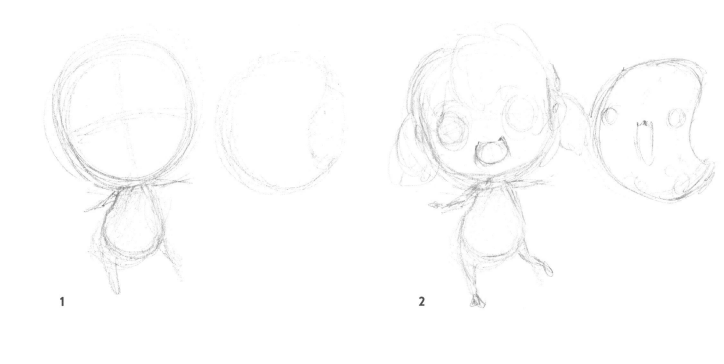

1

2

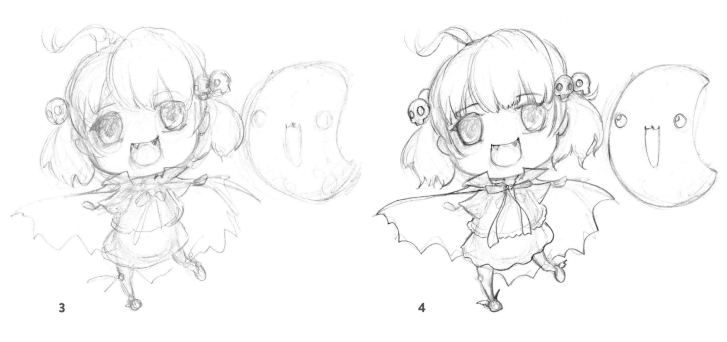

3

4

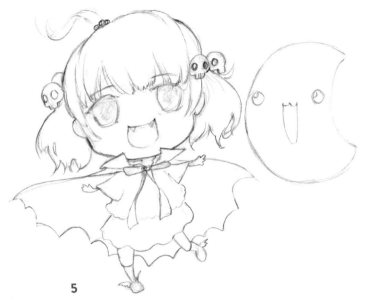

5

6

STEP 5: It's time to erase! Hold your paper down and gently erase the underdrawing. Use a clean, dry paintbrush to wipe away eraser bits. If you use a tool like a paintbrush to wipe away debris, you'll avoid smudging the paper with the oil from your hands. Then, refine the outline of your drawing with a soft lead, which can be any lead from a 2B to a 6B.

STEP 6: Shade your drawing. With the eyes, remember that chibis have huge pupils—it's part of what makes them so cute! Take your time and use a hard lead (such as an F or H pencil) for this step.

MIRROR EFFECT

One method I use to see if I have my proportions correct is to take a photo of my drawing, and then use a photo-editing app (of which there are several available) to flip the image horizontally. You'd be surprised how slanted your drawing can appear without you realizing it! If you don't have a mirror (to which you can hold up your drawing and view it in reverse) or a phone app to help, turn the drawing upside down. Try it and see if that works for you!

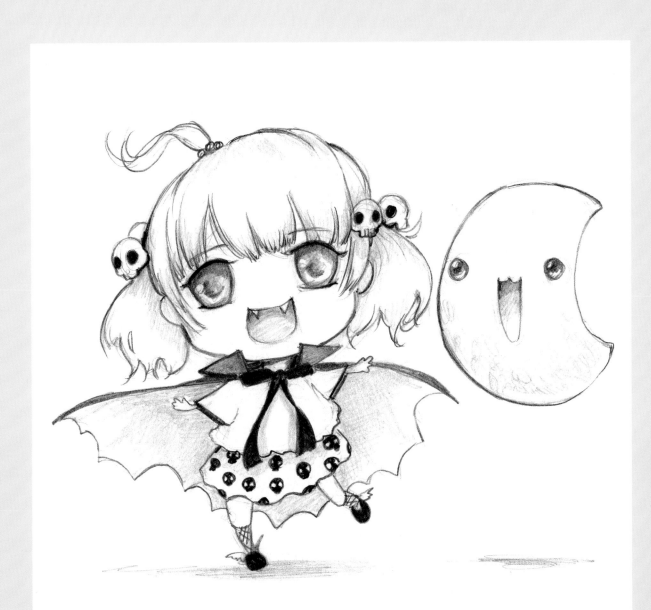

FINAL

FINISHING UP: For this final step, darken some of the lines and add patterns! And there you have it, an adorable vampire chibi with a cute moon friend.

Dear Dapper Daryl

In his painting, Salvador Dalí was famous for depicting solid objects that looked as if they were melting. His work in Surrealism shocked the world. I've never forgotten his images of melting clocks. In my own unique way, I've learned how to melt objects in my artwork. I love to melt color and people in my work. In this lesson, I'll show you how to melt a boy's bow tie. It's going to be so much fun!

STEP 1: Use any lead from an HB to a 2H or B to draw a circle to represent the head. Then, add a simple shape for the neck and torso and a triangular, ellipitical shape for the bow tie. Use light pressure so your lines are faint.

STEP 2: Add details to your character, such as hair, eyes, mouth, and so on. Again, remember to use light pressure and to keep these elements as simple outlines. Refinement comes later.

STEP 3: Refine your drawing by adding more details with darker lines. You can achieve the melting effect of your bow tie in a variety of ways, but I like to show that the bottom is melting while the top has a more solid look.

STEP 4: It's time to erase your underdrawing. Clean up your image so that you know exactly what elements to refine and what additional changes you need to make for your character.

STEP 5: Switch to a pencil that has a softer lead like a 4B (if you're using a mechanical pencil, switch to one with a thinner lead like a 0.3 mm). I like to start with the hair and add lots of individual pieces. The best way to do this is to turn your paper so that you can make long strokes that flow easily. Start at the top with light pressure, push a little harder, and then flick your pencil up to get a thin-to-thick-to-sharp end.

STEP 6: Let's move on to the bow tie. You can have lots of fun with this part. Still using a softer lead (anything from a B to a 3B), try to shape your melting effect so it looks like it sits on the boy's shirt. Follow the contours of the melting effect and darken areas where different objects meet and also darken the undersides of the drips.

Look up images of melting ice cream online to inspire you!

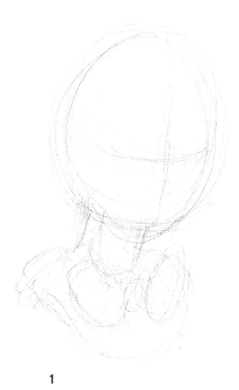

1

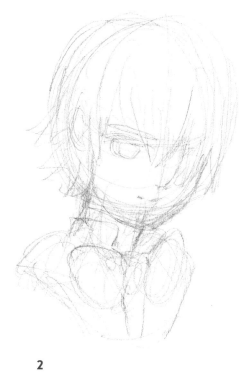

2

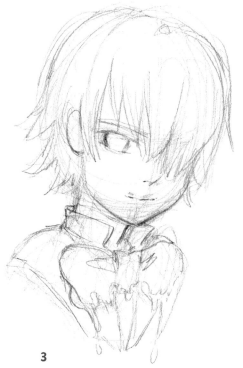

3

4

5

6

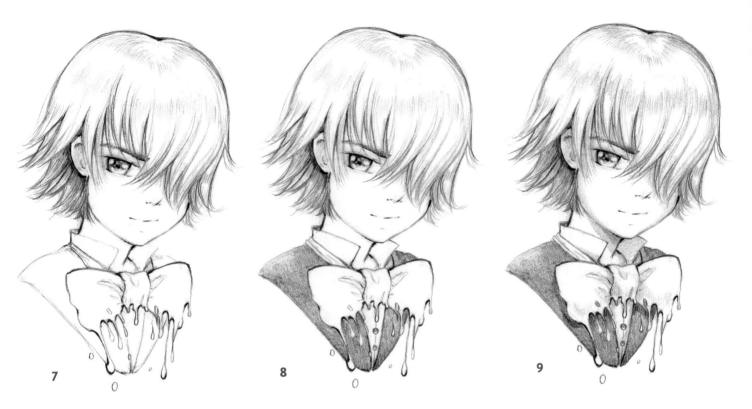

STEP 7: Think about layers when filling in the eye. Start with the highlight in the corner of the eye by drawing a circle. Fill in the eye slowly, using subtle shading that goes from the top to the bottom and from dark to light. Add the pupil with darker marks. Then finish the rest of the contours of the face.

STEP 8: Add some more details to his outfit. You can make his vest pure black or use a pattern. It's up to you! Start shading with soft pressure. Then turn the paper and go over the area again. Repeat this action several times until you get the level of darkness you want.

STEP 9: Time to add some shadows! Shade under his chin, hair, and bow tie.

FINISHING UP: (Opposite page) Darken the edges and contours to tighten up the image. And, boom, you've just created your first ever melting-bow-tie boy!

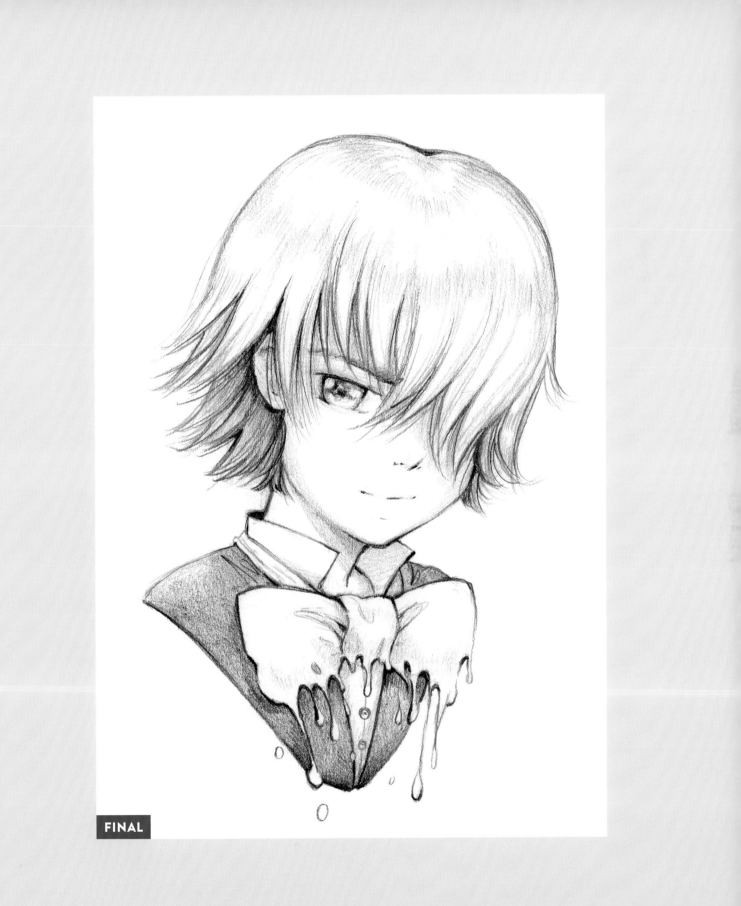

FINAL

Masquerade

For this lesson, I'll show you how to break the rules of reality and have fun while doing so. I'll teach you how to draw the floating head of a girl wearing a Japanese-style fox mask.

The closer the nose is to the eyes, the younger your character will appear. And the further down toward the chin the mouth is placed, the older your character will look!

STEP 1: As with every drawing, start with basic shapes to get the overall placement and size of the elements in your drawing. I use a circle for the head, an oval for the mask, and a few balloonlike shapes for her hair. Remember that with pencils you can erase whatever you want and make sure your shapes are perfect. Use a hard lead (a 2H or if you use a mechanical pencil just press softly), so that your marks are light and easy to remove with an eraser.

STEP 2: Draw a line down the middle of the circle as a way of dividing the face in half. You can use that line to determine which way your character is facing. I used a head-on perspective here, meaning the character faces straight ahead. So, my line runs exactly down the middle. Add a second line that intersects the first one horizontally, that's your eye line.

STEP 3: By using your crosshair lines, you can add the eyes and mouth. The eyes are on the same line as the ears, by the way! The nose and mouth are centered on the vertical line and placed in the lower third of the face. Draw simple marks to indicate these facial features. Don't get too complicated just yet.

STEP 4: For this step, you'll define the edges of the mask. One of my rules is to always draw the items on top first, before moving down to the rest. So, here you draw the mask first because it obscures the girl underneath it. There is no point drawing what's under an object, unless what you are drawing is transparent. Note: The strings of the mask are a fun element to add for movement.

1

2

3

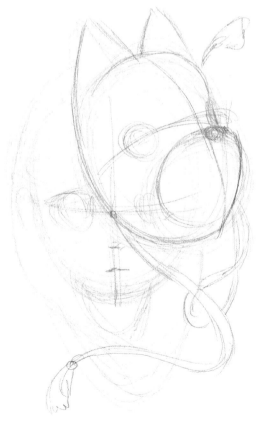

4

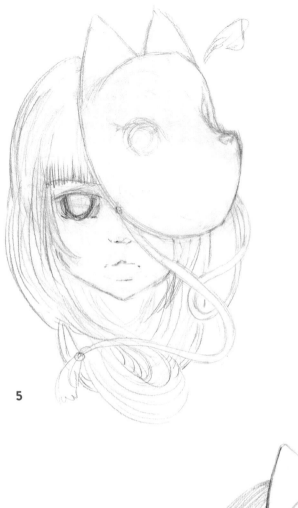

5

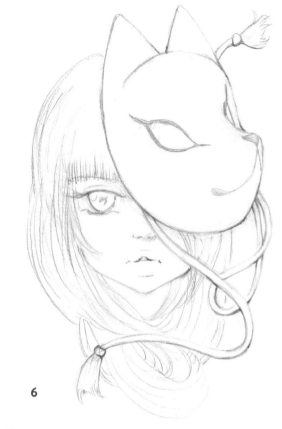

6

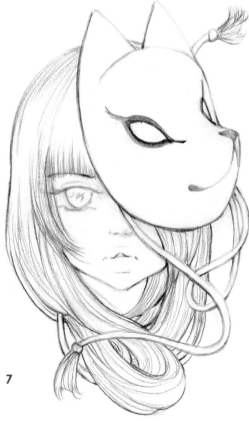

7

STEP 5: Once you establish the elements of the mask, you can focus on the girl's features. Start with her hair, since it's on top of the face. When I draw hair, I always start with the bangs! Work from the bottom of the bangs up, quickly sketching upward with light strokes that barely touch the paper. Don't press too hard because a lot of what you're doing now will be drawn over or erased later. Swirl the hair downward and loosely loop it around itself.

STEP 6: Fill in the girl's face. I like to start with the eyebrows so I can establish my character's mood right away. The more arched the brow, the more emotion displayed. Add the top eyelash first, and then draw

the pupil using the curve of the circle you drew earlier. Then, add a bottom line to indicate the bottom eyelashes and bottom of the eye. The nose doesn't need to change much at this point, but the mouth needs to be defined. I want her to be serious, so I turn down the corners of her mouth to show a sadder expression.

STEP 7: It's time to erase and fix any mistakes you may have drawn earlier. In this example, I realized my fox mask looked more like a dog mask. I had to narrow the shape by shifting the nose over and adding a mouth to the mask.

When drawing string, ribbon, rope, and so on, you can use one continuous line and move your pencil over the paper without lifting it. Or you can use quick short lines to create the edges. Choose the method that works best for you!

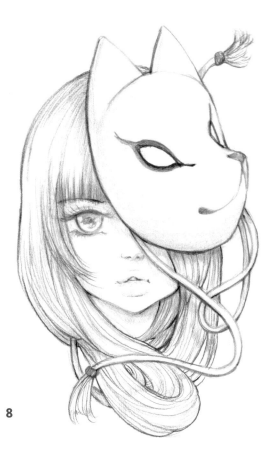

8

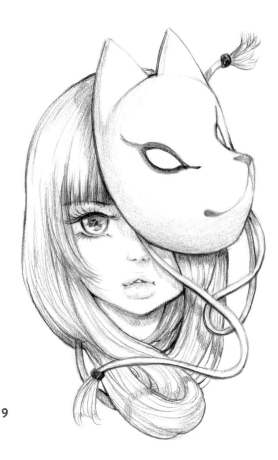

9

STEP 8: Let's refine what you've drawn so far. Draw in the details of the fox mask—the eyes, the nose, and the mouth. It's okay to switch from erasing to drawing as you put in details. Focus on darkening the parts that intersect with each other, such as the corner of the mouth, the strings that overlap, and so on. Doing so will give definition and depth to your final piece!

STEP 9: Using a hard 2H lead pencil, draw in the hair, starting at the tips of the bangs. I use quick strokes from the ends up. I go over my lines several times until I build up a nice amount of lines. Switch to a soft lead 3B for the darker areas. I also use harder leads to shade the mask and add shadows. You can

position your pencil at an angle so that more of the tip rubs on the paper. Change pressure from light to a bit harder to get darker lines at the edges of the objects, and then lighten them to achieve an ombre look (see page 18).

FINISHING UP: (Opposite page) For this example, let's use a little color! Japanese masks often have red on them, but you can choose any color you want. Here, I used a thin paintbrush and gouache paint to add a little red to my mask. Gouache dries as one solid color, so it's perfect for this type of work, but you can use a red acrylic paint as well. Markers are also good to use, if you don't have paint!

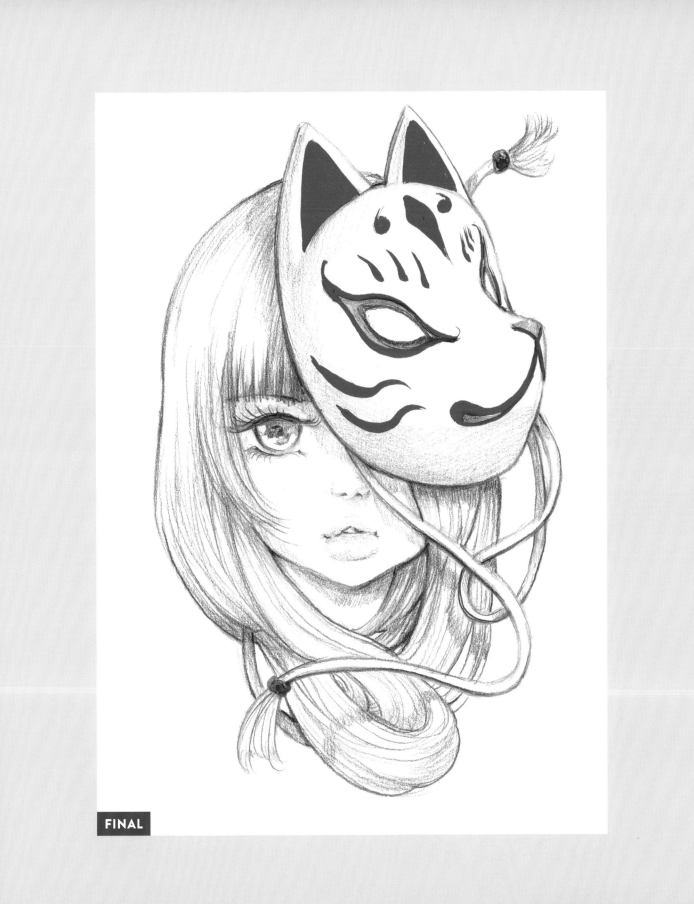

FINAL

Adding Color

Graphite drawings are beautiful. I love the gray and black tones that you can create with them. However, if you want to add a little color, there are several possible ways to do so!

Pencil Crayons

I love adding color to my drawings with pencil crayons (also known as colored pencils)! I do it in very subtle ways, for two reasons: (1) I like the way that the graphite looks when just a hint of color is blended in, and (2) graphite and pencil crayons don't always work well together. Sometimes when you use pencil crayons over top of the graphite, it can create a muddy effect. So my advice is to add the pencil crayons first, then finish up the drawing with graphite afterward.

Markers

There are many kinds of markers, from high-quality to dollar-store brands, from Sharpies to Copics. There are markers with sparkles in them, gel pens, puffy ink, metallic ink, and paint pens. Oh my goodness, it's a buffet for the creative mind! My favorite thing to do with markers is to add solid areas of color to highlight certain parts of a drawing! Be warned: the graphite will muddy the marker. You'll notice the tip of your marker will pick up dark gray stains—that's the graphite, and it can ruin your markers. So try to avoid putting marker directly on graphite.

Acrylic Paint

Acrylic paint is my favorite color medium to add to my graphite drawings! Oh, how I love you, paint—specifically acrylic gouache! For those of you who don't know what *acrylic gouache* is, or have never used it, it's a kind of opaque acrylic paint. The main difference between gouache and regular acrylics is that the former dries completely solid and matte (that means nonglossy).

To give you an example, when you apply gouache, no matter how much you brush on, the area will dry as one flat color. It's also an amazing paint to draw on top of. Unlike regular acrylics, its surface isn't plastic, so it allows for reworking and lets you add pen or pencil. You can also use gouache over your graphite without the graphite muddying the paint. Try it out and see for yourself! But be warned—gouache has the reputation of being one of the hardest paints to work with. So start with small patches and highlights, and then build your way up to more complex washes or additions to your drawing.

Watercolor

When using watercolors with graphite drawing, the trick is to do the watercolor part first. If you try to add watercolor on top of graphite, the image will just get muddy and dirty your colors. If you color first, then you can apply the pencils over top and make your drawing so beautiful. When using watercolors, make sure to use watercolor paper. Make sure it's thick enough to hold the paint and resist warping or tearing from having water added to it.

Doggone Grin

For this fun beginner lesson, I'll show you how to draw a boy character with a manga twist—he's got fox ears! And let's add a surreal twist and draw him as a floating head, with a bow tie whose pattern defies the laws of three dimensions.

In manga, it's okay to draw the eyebrow over the hair. It's one fun quirk of the manga style!

STEP 1: Starting with a harder lead (H or HB) or a mechanical pencil with light pressure, draw a circle to represent the head. Because the character faces us head-on, draw a line down the center of the circle to divide the face in half. Draw another line that's horizontal and crosses over the previous line. These crosshair lines determine the direction your character faces and give you a guide for drawing the features. Add shapes to indicate ears and the bow tie.

STEP 2: It's time to add some furry details! I like to switch things up occasionally and draw the outline of the hair first. Whatever method you choose, remember to lightly draw in the edges of the bangs and hair. At this step, you're establishing the length and style, so keep the lines light and easy to erase and redraw later.

STEP 3: Let's indicate where the facial features will go. Working from your crosshair lines, add oval shapes to indicate the eyes. In manga, boys have narrower eyes than girls, so be mindful of how big you make his eyes here!

STEP 4: At this stage, things really start to come together! Draw the outline of his chin and define the facial features more. The chin should come to a point at the bottom of your circle and the cheeks should follow the curve of the circle (almost like you're drawing the bottom of a heart). But do keep in mind that you don't *have* to have a pointy chin. Note: The wider the chin, the older the character will appear in manga-style art.

STEP 5: Let's get hairy! Or let's get to work on the ears and the boy's hair at least. When drawing furry ears, keep your marks quick and light. Start from the base of the hair and flick upward so that your line goes from thick to thin (like actual hair does!).

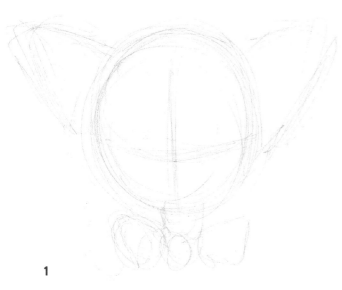

1

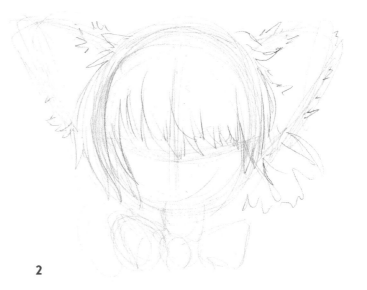

2

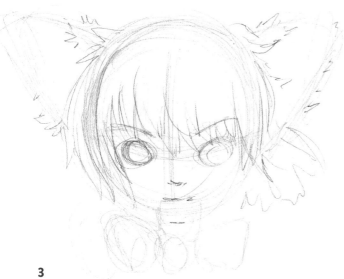

3

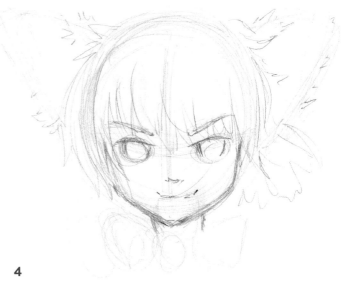

4

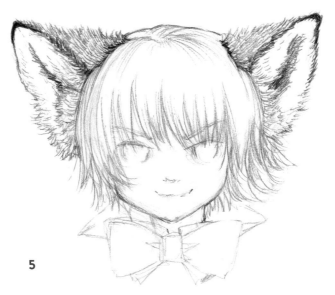

5

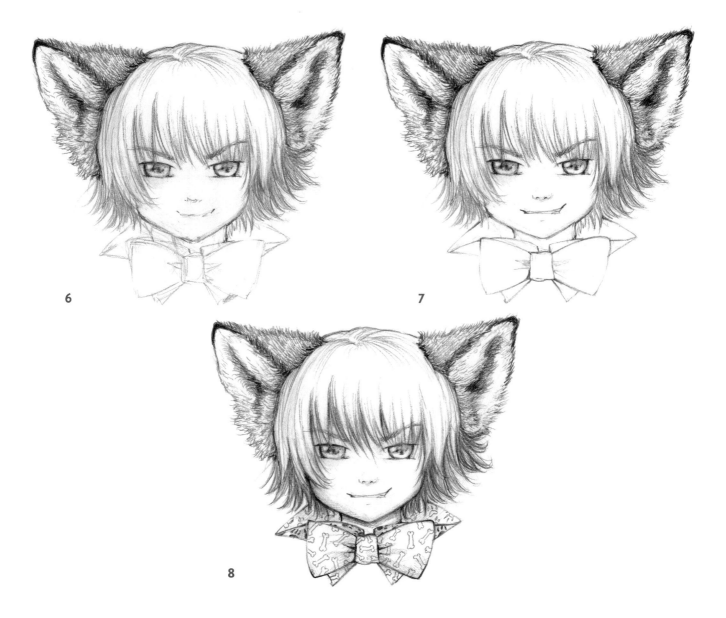

6

7

8

STEP 6: Add more detail on the bow tie and erase some of the underdrawing. The bow tie is a simple shape with two creases near its center. Erasing is important here so that in the steps ahead you can draw in the details.

STEP 7: Using quick little flicks of your wrist, fill in the ears with fur. Move fast and draw the fur in a line. You can draw over the marks, so don't worry about being perfect. At this stage, you should also draw in the bangs. With longer bangs, you work in the opposite direction and start from the top of the hair and draw down to its tips. Keep pressure light

and sweep your pencil off the page so that the tips look wispy. To draw in the eyes, start with a highlight, a small circle within the iris placed at the top left corner. From there, gradually add shading from the top of the iris, lightening as you reach the bottom. Then, draw in the lower eyelid without lashes.

STEP 8: Use your eraser to clean up the bow tie. Use a soft lead pencil, a 2B, starting at the edges of the bow tie, to add darker lines. Doing so adds depth. Using that same approach, draw in the chin and mouth and nose.

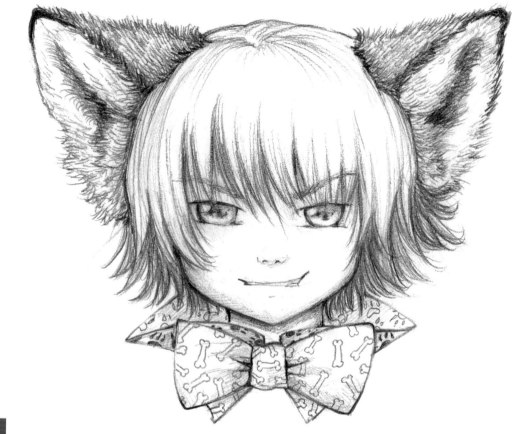

FINAL

FINISHING UP: Add shadows by using soft pressure and meticulously drawing gradient dark areas—under the chin, the hair, and any other areas that would cast a shadow. I chose to fill in the bow tie with dog bones to have a little fun with the theme!

PHOTO REFERENCE

Not all of us have photographic memories. (Kudos to those of you out there who do—I'm jealous!) It's okay to use photographs as reference while you draw. I like to have up to ten different pictures to look at when I'm drawing an animal or object that I haven't mastered yet. Just remember not to copy the photo exactly, unless it is one that you took. Otherwise you are copying someone else's art. Yes, photos are art too, and copying someone else's photo is plagiarizing!

Ladybird Man

Let's mix things up a bit and throw some mythology into your Pop Manga drawing! I'm excited to show you how to draw a simple, yet charming character—a unicorn boy with buggy friends. This might seem like a hodgepodge, but it all has meaning! What you draw is really important because it conveys a story about your character. Imagine that each part of your character and the elements, as in the objects or patterns for example, are part of the visual story you are trying to tell. Everything can have a meaning, so think about what you will draw before you add it into your image. I chose ladybirds to convey his sense of gentleness and romantic nature. Within those little bugs, I added patterns to show that he is playful with each bug representing a different kind of love in his life.

When you draw hair, imagine there's a wind machine pointed at your character. The flow will bring an element of movement and excitement to your drawing.

STEP 1: Either using a hard lead (HB) or applying soft pressure with a mechanical pencil, start outlining the simple head shape—an oval with crosshairs, the neck, and the shoulders. Beginning with basics gives you a solid foundation to work from in the steps ahead.

STEP 2: Add the details that will make your drawing super special and unique to you! Use simple shapes and rough outlines to draw in your character's horn, hair, facial expression, and surrounding little critters (in that order!).

STEP 3: Refine your details. I like to use a softer 3B pencil here to achieve darker lines.

STEP 4: Erase the underdrawing. It's important to clean up your drawing so that you know exactly what to draw. Switch to a softer lead (4B). If you are using a mechanical pencil, switch to a thinner one, 0.3 mm. Here, I give the surrounding bugs some more personality. In manga, creators love making everything cute. So start making things adorable by giving them big eyes and chubby legs.

STEP 5: I prefer to define parts of my drawing one at a time. Here, I fill in details by focusing on the edges and outlines. In a slow and steady manner, outline your drawing. Think of it like tracing.

STEP 6: Focus on the bugs for this step! Let's add a Pop Surrealist twist and give them fun shapes instead of the standard polka dots. I switched to a pencil with a soft lead (2B), and colored them in, changing pressure from hard to light to get different tones.

1

2

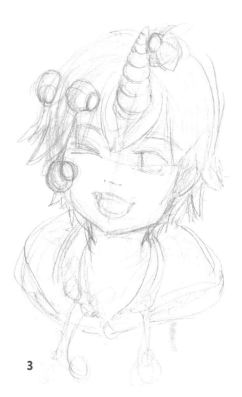

3

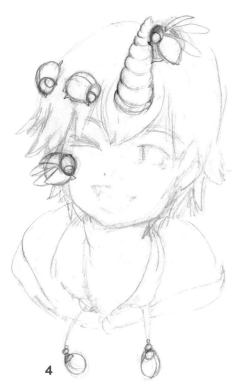

4

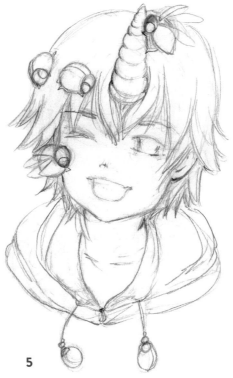

5

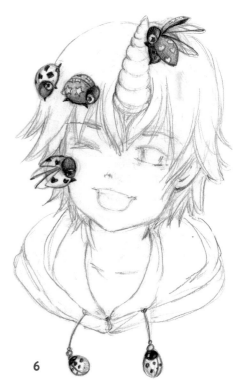

6

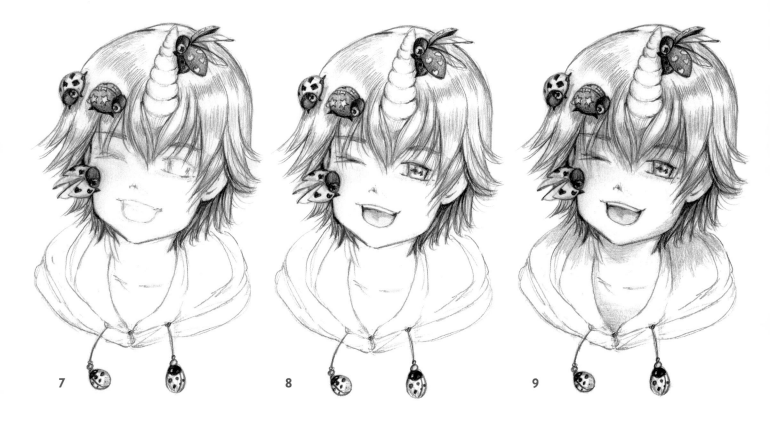

7

8

9

STEP 7: Time to get your hair on! Adding details is all about patience. Start at the top of the hair and add highlights using fast strokes of a hard pencil lead (or a mechanical pencil with a thinner lead). Then, draw in the tips with the same quick light strokes.

STEP 8: To finalize the hair, switch to a softer lead to achieve the dark lines that will help you define the edges.

STEP 9: Add in shadows and shade in the darker areas. Try to make your shadows resemble the hair.

FINISHING UP: (Opposite page) Spend some time tightening up the drawing by going over your darker areas and edges. Then, voilà, you are done with your drawing!

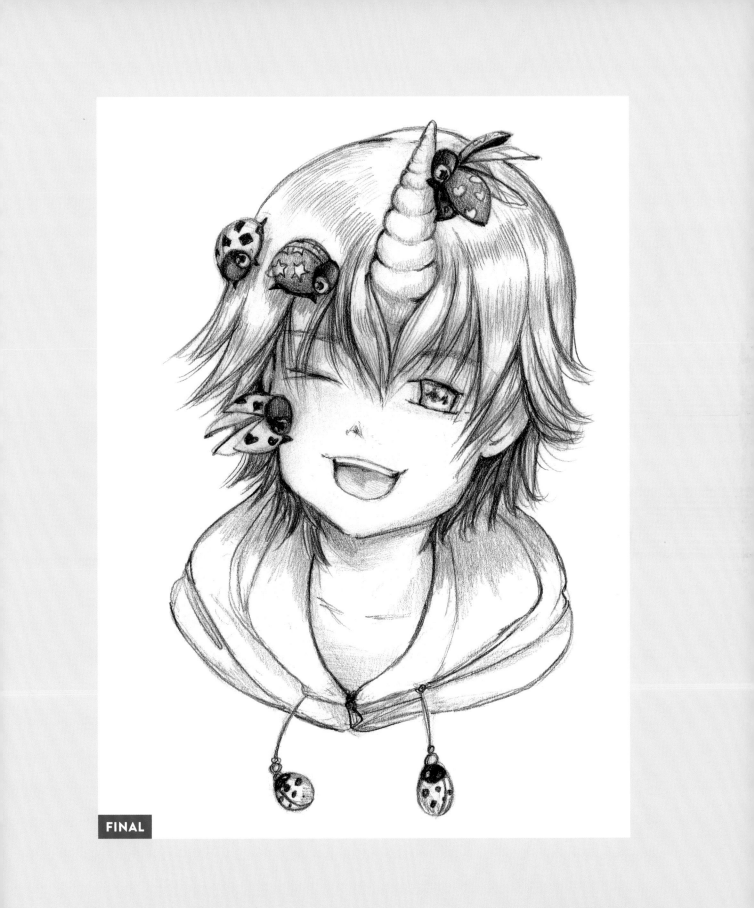

FINAL

Watermelon Madness

One of the go-to surrealist elements in my work is the blending of two things that cannot exist together in our world, but that together, breathe life into a new creature. That's how something like this watermelon butterfly was born! I've blended butterflies, bees, and flies with fruit for years. It's so much fun! Try blending your own crazy creations and see what happens!

Change the direction of your lines so that you can create a more even shade. I like to turn my paper while I'm shading to achieve this effect.

STEP 1: With a hard lead (HB) or using soft pressure on a mechanical pencil, start by drawing the butterfly's body and then its wing shapes. I start with a balloon animal-like shape for the body and make simple shapes to indicate the wings. Make sure you can see both sides of the wings so that you can show off the outside of the wing as well as its underside.

STEP 2: Further define the shape of your butterfly. Keep in mind what the inside of a watermelon looks like and try to blend that with the butterfly's wing pattern. I'm using a monarch butterfly as my inspiration, exchanging the black part of the wing for the rind of the watermelon.

STEP 3: Switch to a soft lead 4B pencil to darken the outlines. Use your eraser to remove the underdrawing.

STEP 4: It's time for the main event—the juicy watermelon part! You'll need to shade twice for this step. First, start with the outside and slowly work your way inside. Apply light pressure to establish your fruity center, then go back and darken the edges.

STEP 5: For the first layer of shading inside of the wing, use a hard lead (such as a 2H or HB). As with a real watermelon, you want the center to be darker. I like to keep my pencil as low to the paper as possible and hold its end so that I'm not gripping too hard and accidentally making dark lines. It takes time, so be patient!

STEP 6: Let's shade the rest of your butterfly. Here, I still recommend using a hard lead because you'll need this area lighter for the next step (where you'll add in the pattern of the watermelon skin).

1

2

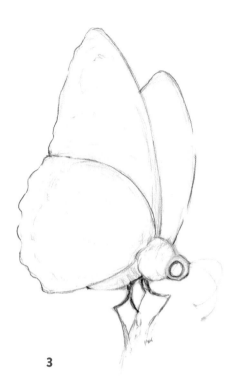

3

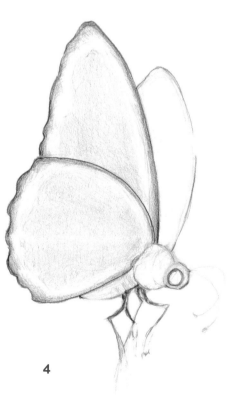

4

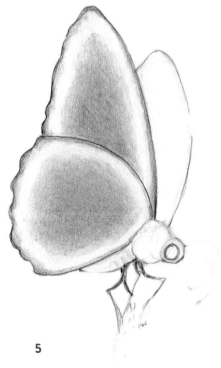

5

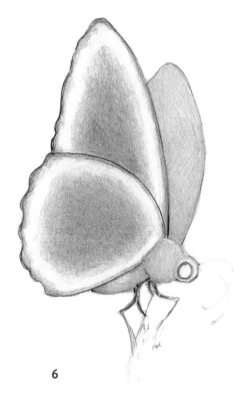

6

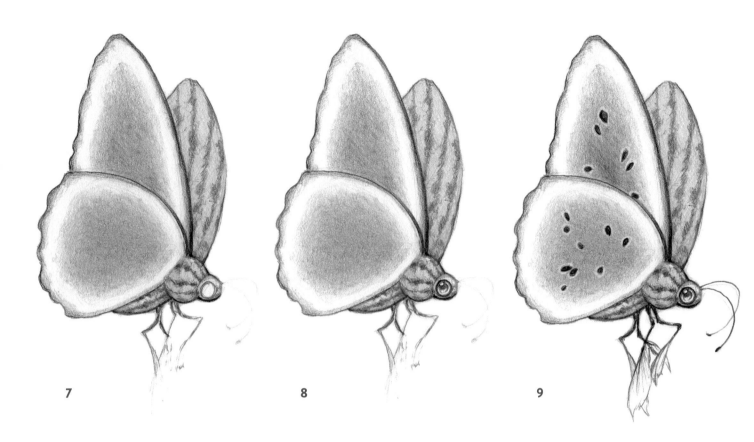

7

8

9

STEP 7: Switch to a softer lead like a 2B (or use harder pressure on your mechanical pencil) for this step. Slowly add the veins of the watermelon, following the curve of the body and the wing. Start with a lighter line, and then go over it several times until you achieve the darkness you want.

STEP 8: Time to draw the eye! In manga, round insect eyes appear much like a human's, just with no eyelids! Start with the outside circle, darken it, and then add a small circle for your highlight. From there, move from the highlight toward the center of the eye. Shade it and add a pupil.

STEP 9: Add details like the seeds and legs (I turned mine into leaves). For the seeds, use a soft lead (such as a 3B) to get some dark marks. Finish them by taking an eraser and carefully removing some of the graphite from around the seeds.

FINISHING UP: (Opposite page) Add in shadows by shading in the underside of the butterfly. Then, use your eraser to lightly dab away a few areas near the outside wing and body to create a highlight effect. Booyah baby, you've just drawn a watermelon butterfly!

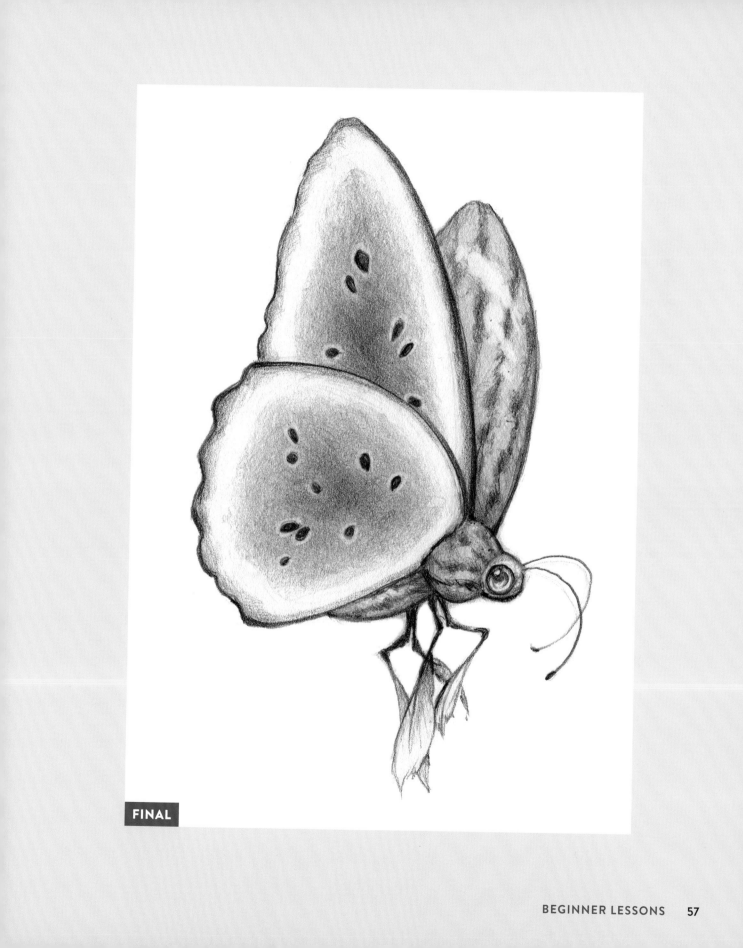

Angry Flower Power

Blending two styles is easy, when you bridge the gap by finding a common denominator! One of the fun parts of working in Pop Surrealism is bringing to life objects that are just accessories in the real world. Manga is famous for bringing inanimate objects like toys to life and giving them personalities. So, for this lesson, let's draw a girl with a hair clip that shouldn't be alive, but is!

Consider how the contrast of emotions between the girl and her flower makes for a very dynamic composition.

STEP 1: Using a hard lead (HB), draw in your shapes with very light pencil marks. First, draw in the head shape as a circle and add your crosshairs. Then roughly sketch in shapes for her flower and her braid.

STEP 2: Add the details for her eyes and the rest of the face by following the crosshairs. Her face is tilted up slightly, so her features should be placed higher up on the lines. Adjust the angle of her chin as well. Add a few petals for the flower. You can choose any flower you like. I chose to use a daisy, since it's a simpler shape and won't take away from her face.

STEP 3: Let's get that braid going! In life, these braids are three layers of hair twisted together. But the actual look here is different. It looks like there are only two pieces of hair folding over each other. Keep that in mind as you work. Each chunk should fold over the other and end with the hair tied together with a ribbon.

STEP 4: Now, define the flower, as it's the one object sitting above all others. You can make the flower's face appear however you like. I chose to draw a super cute, angry little face. Start with the crosshairs and add the features on those lines. You can also fill in some of the detail of the petals.

STEP 5: It's time to erase your underdrawing and reinforce the outlines with a soft lead 2B pencil. Be careful while erasing: make sure to hold the paper with one hand while you gently erase with the other. Use a brush to wipe away the little bits of eraser left behind.

STEP 6: To flesh out your drawing, use a soft lead 3B and work on the contours. I chose to start at the edges of the petals and used quick strokes to darken the outline.

1

2

3

4

5

6

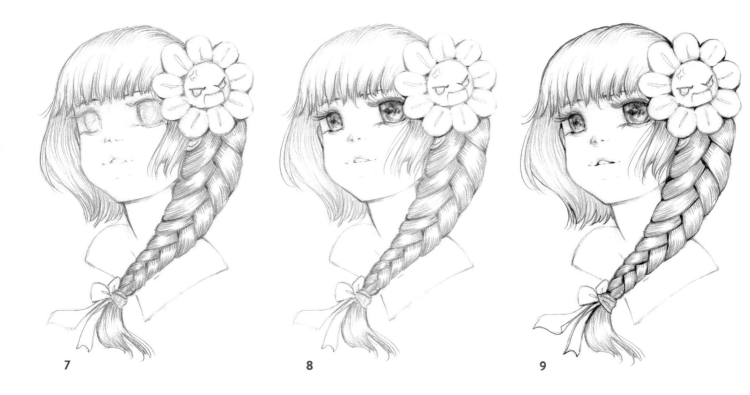

7 8 9

STEP 7: When drawing the hair in the braid, start at the bottom and swish your pencil stroke up, lessening the pressure as you near the center. Repeat from top to bottom as you add in hair lines.

STEP 8: Drawing the eyes is all about shading. Start at the top of the eye and move inward, changing your pressure to move between dark and light.

STEP 9: With this step, intensify your dark edges and lines before the shading. At this stage, I make sure to use a soft 3B lead with a sharp tip.

FINISHING UP: (Opposite page) At the final stage, add in more shadows and shading. I use a combination of a hard 3H lead and soft 3B lead. Doing so allows me to do both light shading and dark shading. And once you add these elements, you're all done, baby!

You can use your eraser to add in highlights to the hair!

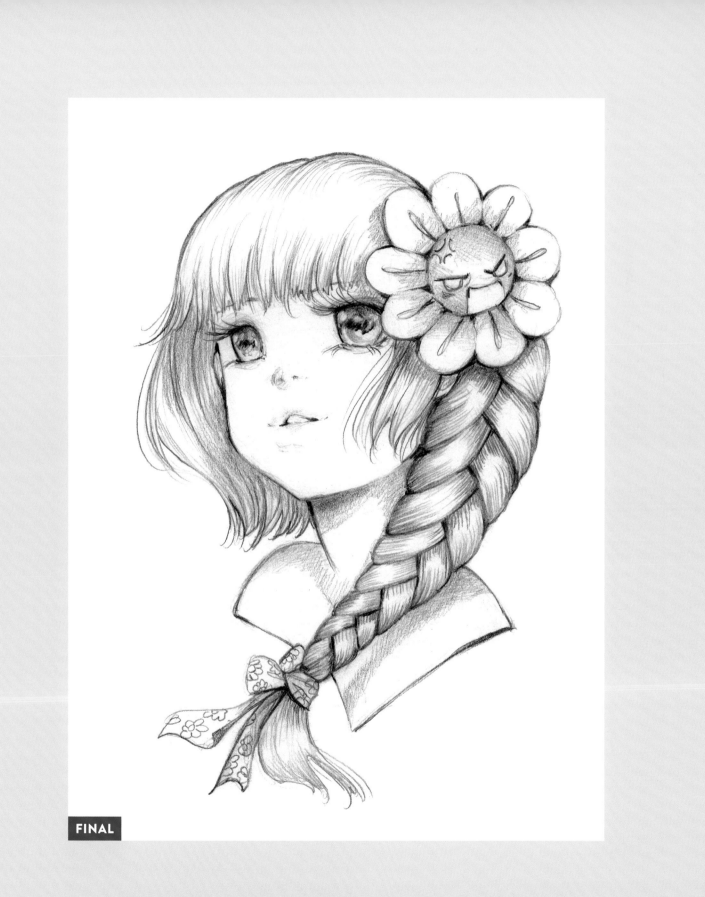

FINAL

Fun in the Sun

Imagine a world where half of your face is covered in long, luscious hair and you have a bunch of cute friends who also happen to be suns. Sounds awesome? Let's draw it!!

To achieve a three-dimensional appearance in your drawings, layer objects in front of and behind other ones.

STEP 1: For this piece, you're going to draw a full circle (even though half of the face will be covered up by hair) using a hard lead like an HB or by gently drawing so you don't press too hard. It's important to have the proper shape and structure of all objects no matter if you see them or not!

STEP 2: Use light lines to add details to your character. Don't press too hard, okay? The trick here is to establish the hair first and then fit in the sun buddies after. So, don't be afraid to draw over your initial circle shapes.

STEP 3: Refine the elements of your drawing either by switching to a softer 3B lead or by adding a little bit more pressure to your current pencil. You want to focus on the ebb and flow of the hair. Using confident strokes, try to maintain a continuous line, breaking only when you get to a juncture. I start at the bangs and then move down to the rest of the hair.

STEP 4: Erase your underdrawing with a soft eraser. It's okay to erase some of the outlines you've established. Now's your chance to correct and redraw parts!

STEP 5: Work on one object at a time. I chose to focus on the girl's eyes as well as her bear ears. Use quick little strokes to simulate fur. Shade in her eyes moving from top to middle. Drawing the eyes and ears will require several layers of shading and texture.

STEP 6: Refine the suns. I chose to draw the suns before the hair because the suns overlap the hair. As a result, it's best to establish them first. Use a softer 4B lead to achieve darker lines and gently go over your outline. Thicken the lines that connect at the main subject to provide more definition. Give each sun a little face to add some personality.

1

2

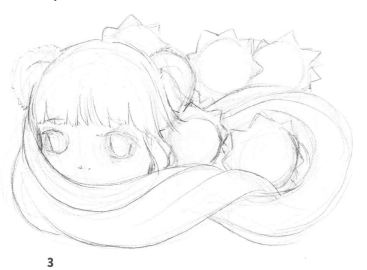

3

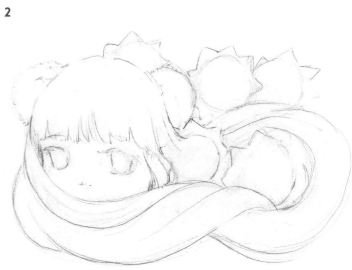

4

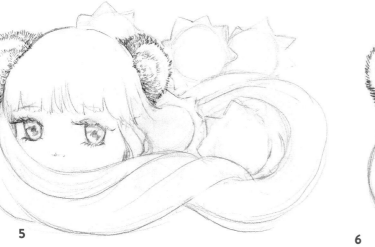

5

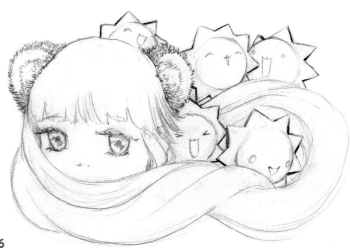

6

7

8

STEP 7: Now, jump into the hair! For this stage of the drawing, turn your paper around as you draw to get nice, fluid lines. Start with light, subtle lines to get a feeling for the hair. Then, as you get confident, firm up your pressure and draw in more strands of hair. For stylistic purposes, I like to add more hair at the edges and leave less of it in the middle.

STEP 8: Using a softer 4B lead, finish up the eyes, the ears, and the hair. Remember: It's totally okay to draw over the lines placed earlier. Doing so just adds more texture and depth. For the eyes, make sure to darken the tops of the irises so that she doesn't have a startled look. Slowly build up shadows. Start with light pressure, and then turn your paper and draw over that area again with firmer pressure. Repeat this process several times until you get a nice shadow layer.

KNOW YOUR LIMITS

If you start to feel overwhelmed, take a break. Come back with fresh eyes. I've learned that if I don't step away, I'll get so frustrated that I'll erase or destroy the entire drawing. Maybe it's the Italian passion in me. But to avoid this destruction, I always walk away when I'm getting upset.

This method also works when you think things are going great! I call it *tunnel-visioning*: when you paint for so many hours and you think it's so incredible and amazing that you don't see your mistakes. Again, it's always a good idea to take a break every couple hours.

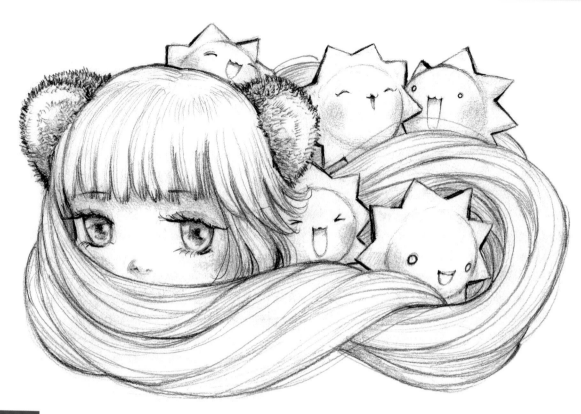

FINAL

FINISHING UP: Go over your drawing and add in darker edges and lines. Clean up any leftover underdrawing and add little wisps of hair here and there.

Madame Butterfly

One of the great things about Pop Manga is that you can add completely bizarre elements to your drawings and turn them into fine art as a result. I love to draw and paint butterflies and moths with eyes on their wings. For this lesson, let's take that concept and then create a kinda-sorta mask that a girl is wearing!

I'm awesome, but also delicate. So treat me with care, okay, lovelies?! Make sure your skin doesn't touch your drawing, or else it'll smudge!

STEP 1: Using a midrange lead (HB, B, or F), start with a circle for the head and draw the crosshairs so you know where to place the mouth and nose. You will not have to draw the eyes. Draw in the neck and the round outline of hands.

STEP 2: Instead of drawing the eyes, you can add shapes to represent your butterfly! Try to place the wings so that they cover up the eyes as much as possible. You'll also want to add shapes for the girl's hair and collar.

STEP 3: Here, it's important to fill in the facial features that you *can* see, the mouth and the nose. Fill in more of the hair and collar as well. Keep your lines fluid. You want the hair to appear soft, so draw it with loops and swirls that cascade downward. Focus on the strands of hair and on getting as much flow in your lines as you can. Work on the hands, making sure that the collar and the hair sit on top of them.

STEP 4: Contour your drawing with a soft lead 2B pencil or a thicker mechanical pencil, 0.7 mm. Focus on the outlines that you want to keep. It's okay to redraw parts if you need to. I also really like strengthening the lines of intersecting objects like the hair in the hands, for example.

STEP 5: Erasing time! Take out as much of the underdrawing as possible. Use an old paintbrush to wipe away the bits of leftover eraser.

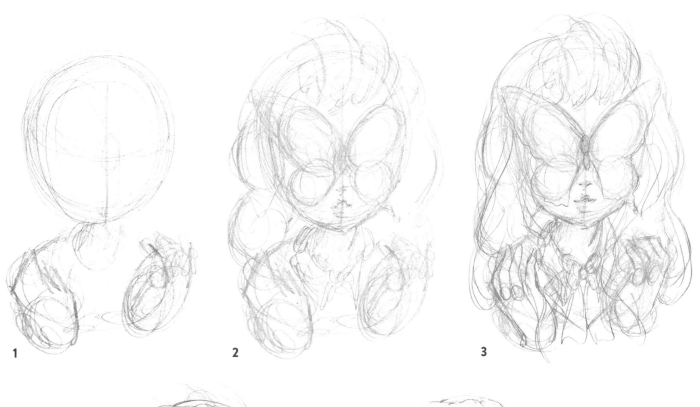

1

2

3

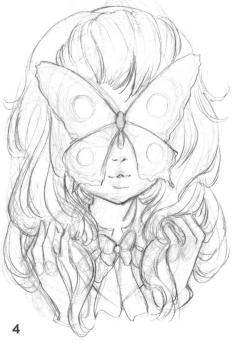

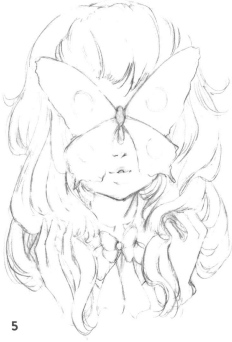

4

5

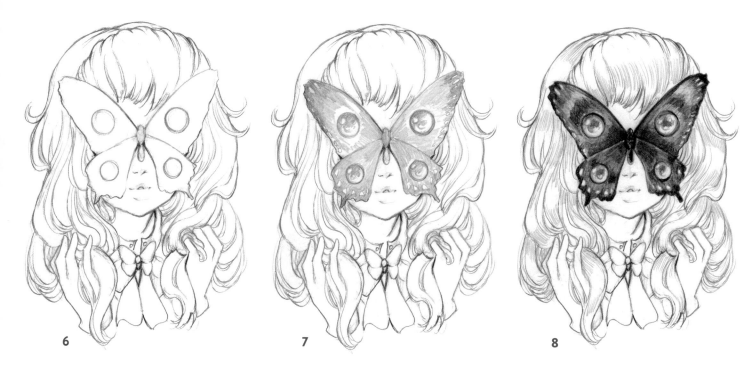

6 7 8

STEP 6: For this step, redraw any parts of the main drawing that you may have accidentally erased when removing the underdrawing. Tighten up and refine your line work. Make sure your outlining is impeccable!

STEP 7: Focus on the butterfly. Filling in a super dark element in a drawing requires the use of a soft lead. I recommend moving from an F to a 4B pencil. Doing so will give you nice dark shading right off the bat. It's tricky, though. If you press too hard, you can see your lines, so, be gentle.

STEP 8: For this stage, use a 4B pencil to fill in the rest of the shading for the butterfly. Then, either switch to a mechanical pencil or sharpen your graphite pencil in order to add in details for the hair. Move quickly over the surface and focus on the tips and mounds of the hair.

FINISHING UP: (Opposite page) For this final step, add shadows with a soft lead 4B pencil. I like to use a soft lead to fill in darker details. Because this drawing has very intricate hair, make sure to take your time filling it in!

FIND YOUR ARTIST'S CAVE

Creating art takes concentration. I like to find a state of Zen before creating art. Establish a space that has great energy and that lifts your spirits. Fill your creative space with art you love and things that inspire you.

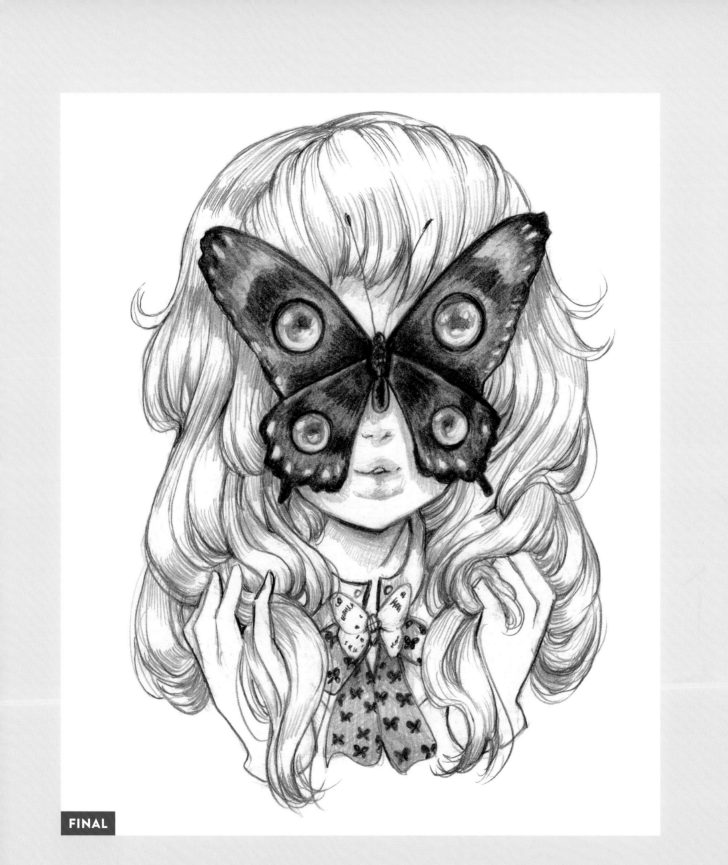

Mushroom Cap Captain

Sometimes it's fun to draw bizarre, nonsensical things! I look at hoodies, and think, *Man, those kinda look like mushrooms!* So, let's draw a mushroom boy and see how far we can take my bizarre idea.

Your underdrawing is what we in the biz call the skeleton of the drawing—it's the backbone of your art that supports the entire structure of your drawing!

STEP 1: Draw your shapes with a light 2H pencil lead. Use a circle for the face. The hoodie is going to be a little frilly, like the underside of a mushroom. Draw a bowl-like shape on top of those frills. It doesn't have to be perfect. This is just an outline.

STEP 2: Tighten up your drawing by adding details for his face, hair, and outfit. You want to use light marks so that you can erase them when we get to the next steps, which will require more details.

STEP 3: Erase the underdrawing so that your final rendering will be free of as many unnecessary lines as possible. Make sure to hold your paper down with your hand or a paperweight as you do so. Be gentle, switching from large erasers to smaller ones to get in the tough areas.

STEP 4: Let's draw some hair! In manga, boys' hair is more angular, messier, and less wispy than girls'. To achieve this look, take a really sharp pencil and start drawing the hair from top to bottom with long, fast strokes for each hair strand. Draw over and darken areas where the hair comes together, such as the area near the neck and the base of the bangs.

STEP 5: In manga, girls' eyes are always big, round, and expressive. Boys' eyes, however, tend to be narrower and sharper. That said, you draw both types in the same way! Start with the upper eyelid and work your way down. Don't make the eyelid line too thick and avoid drawing lashes. Remember to draw thicker eyebrows for boys than you do for girls!

STEP 6: Using a soft lead, work from the outside in to shade your mushroom. Change the pressure from hard to light, moving from the corners and edges to the center, and repeat until you achieve the desired darkness. You'll need many layers, so take your time.

1

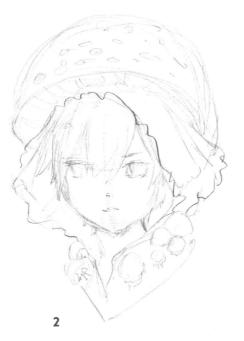

2

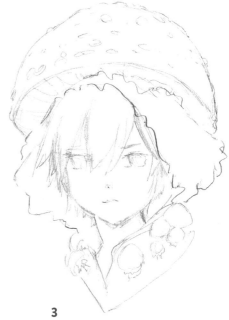

3

4

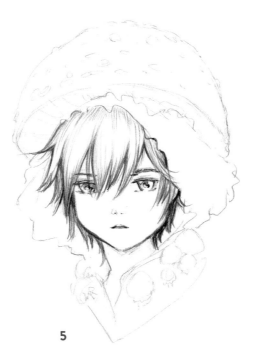

5

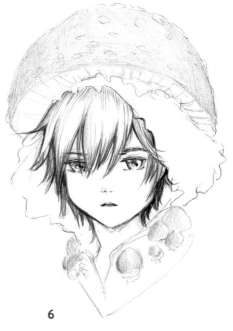

6

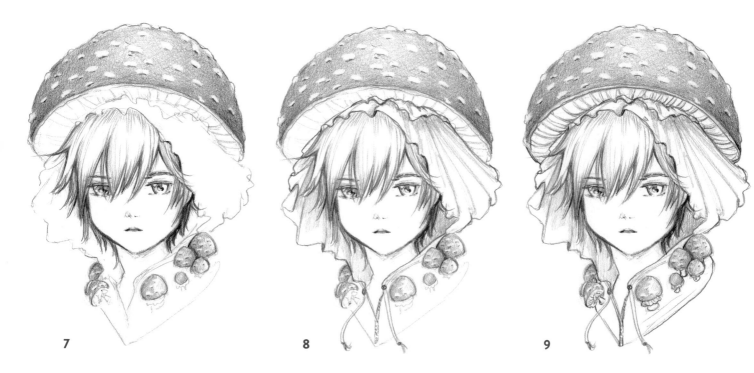

7

8

9

STEP 7: This boy's hoodie is a going to be a red mushroom with little flecks of white on its surface. To add these flecks, use your eraser to remove parts of the shading and then define the flecks.

STEP 8: Fill in the shading for the hoodie by taking a soft lead 2B pencil and turning it sideways. Then rub it slowly and lightly to achieve a shadow effect. Follow up by turning your pencil vertically and adding pressure to draw in dark lines where the fabric folds.

STEP 9: Draw the underside of the mushroom. Start from its inner edge and move to the outer edge. Use sharp, confident strokes to connect the two edges. Repeat until you have a ripple chip effect!

FINISHING UP: (Opposite page) Add silhouettes by shading areas covered by objects casting shadows. Take a red pencil crayon and gently add color by using your shading technique. Start from the base of the mushroom work your color inward. Repeat that several times until you achieve the amount of color you are happy with! It can be subtle or intense, depending on how many layers of color you add. Then darken some of your areas to give depth and, voilà, you have drawn a mushroom boy! Now the hard part . . . what to name him???

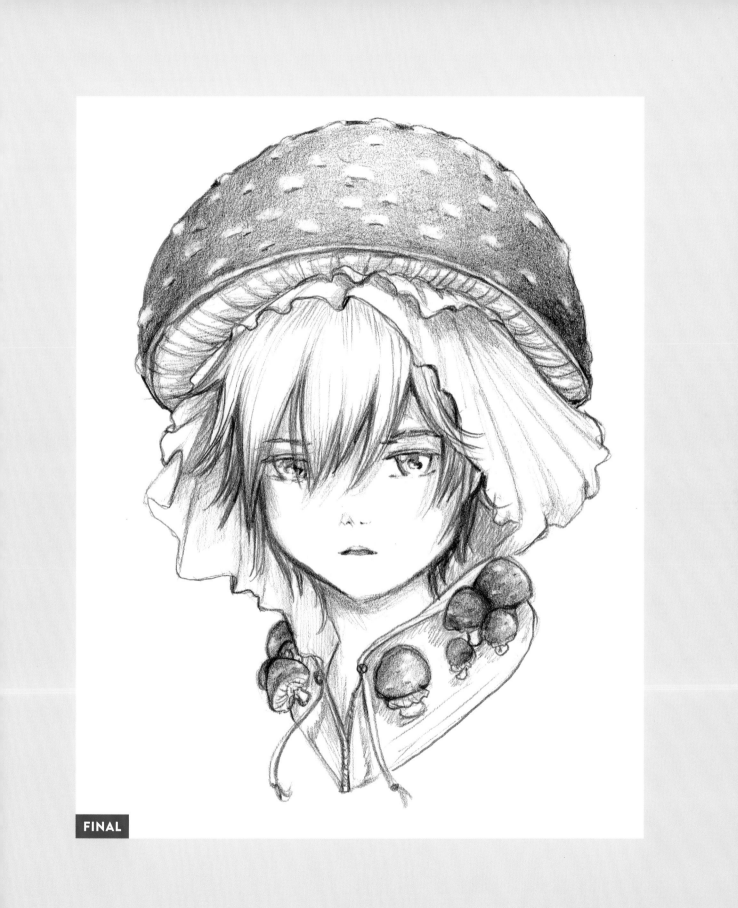

FINAL

TWO

INTERMEDIATE LESSONS

Now that you've mastered the basics, it's time to step it up a notch! In this section, you'll take several of the lessons you learned in the first batch and blend them together. The important thing to remember is to explore your creativity! Each of the drawings I've created is meant to elevate your technique and creativity. Push yourself to do more in this section. These lessons are more complex, so they'll take you longer. Have patience. Take your time and don't rush, and always remember to have fun!

Fuzzy Bee Family

It's fun to create a scene with your characters. So, for this lesson, I'll show you how to put multiple interacting characters together in a scene. Drawing characters in an ensemble can be tricky. But challenge yourself to create art that's complicated and sets a scene: it creates an interaction with your characters and the audience!

Start drawing the objects that sit on top of others first. Doing so keeps you from having to erase and redraw unnecessarily.

STEP 1: Establish the basic shapes of your characters using a light lead; I use an HB pencil. Start with a cute drawing of three baby bees giving flowers to their mamma bee. Balance your drawing by clustering the three babies on the left and the big mamma on the right. Note: You can balance a drawing by grouping sets of characters that are relatively the same size. The babies together are almost the same size as the mamma.

STEP 2: Use your HB pencil draw the eye shapes of bees. The babies will have much bigger eyes than their mom. It's a nice trick for establishing the ages of your characters. Here you'll want to establish how much of the babies the viewer can see. When drawing multiple characters, it's important to retain *spatial awareness* of them (the distance between each character). It's okay to erase parts of their bodies in order to make sure they're placed correctly.

STEP 3: For this step, let's focus on the expressions. Make sure that you position the mamma's head so it looks like she's facing all of her babies. Ensuring that your characters have proper sight lines to each other goes a long way to establishing your scene. Eye contact is everything! Switch to a softer 3B pencil so that you can get darker lines at this stage.

STEP 4: Here is your chance to make sure you properly "layer" your drawing. With multiple characters, you have to think three dimensionally, so start with the object closest to you and draw that in first.

STEP 5: Now focus on the second baby bee. One way to show dimension in your art is to have characters and objects overlapping each other in the scene. So, let's have the second baby bee cover up parts of the third. You'll find yourself thickening up the character lines that intersect with each other. In order to show proper spatial depth, thicken up the lines of the object in the front relative to what's behind it.

1

2

3

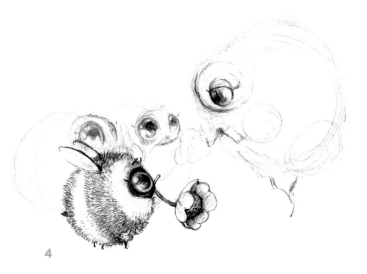

4

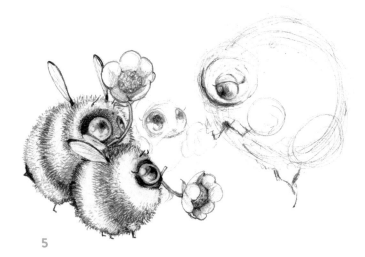

5

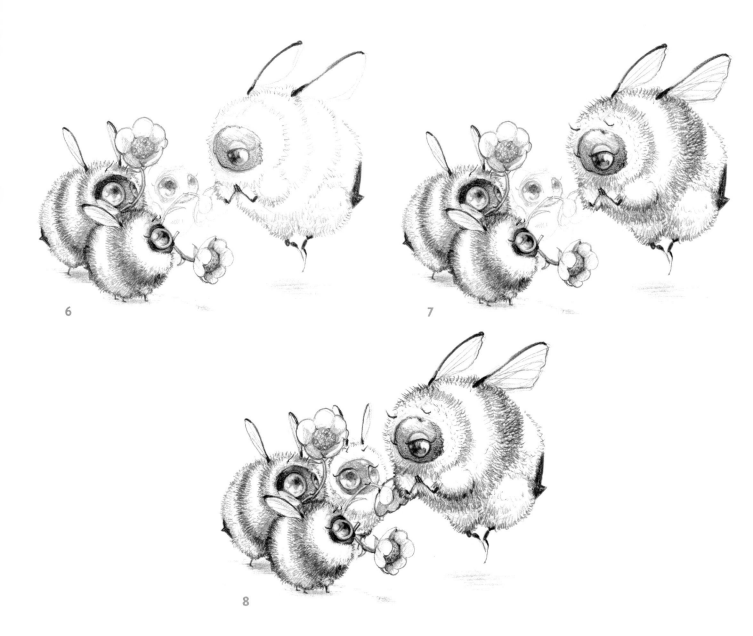

6

7

8

STEP 6: Draw in the mamma bee. Add shadows to the characters where they come close to each other and underneath all of them. If an element is close to or hovering over another element, then adding a shadow from that object really makes it appear as though they are all there together.

STEP 7: Once you've drawn in the body of the mamma, you can continue to add in her fuzz. Keep your marks light and quick as you fluff up her body.

STEP 8: Draw in the third baby bee and add more details to the rest of your characters.

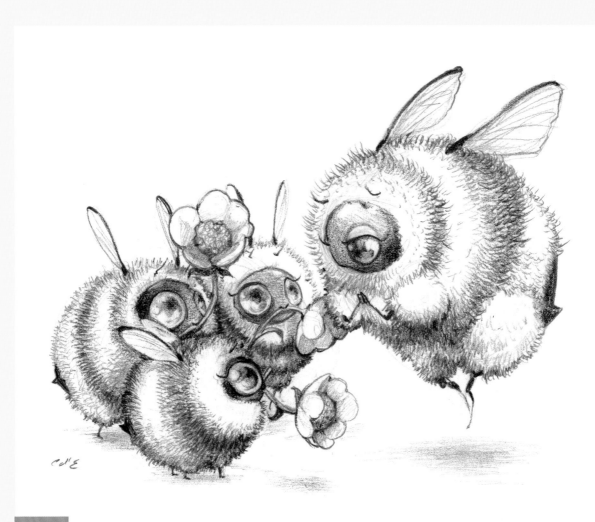

FINISHING UP: Take your time to complete this drawing. Sharpen edges and add more shadows. Focus on adding depth and make sure to keep those fuzzbutts fluffy! #itssofluffy

WRIST HEALTH

Your body is your tool, so keep it sharp. That's especially true for your wrist! Wrist strain is caused by overuse of your muscles and ligaments. I suggest stopping every fifteen minutes to massage your wrist, while you're working. You can also find exercises online for maintaining strong wrists. An ounce of prevention is worth a pound of cure!

Meowzers

One of the many fun things about drawing manga in a surrealist style is that you can twist reality! Instead of just drawing a smiling girl, let's draw a smiling girl with cat ears. Instead of buns of hair on her head, let's give her yarn balls!

When drawing wiggling objects or creatures like yarn or snakes, try using short, quick strokes to develop your line. It gives ya more control, baby!

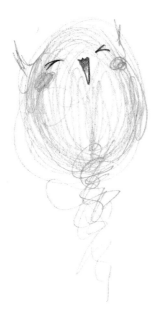

STEP 1: Start with a basic circle for the girl's head using a hard lead like an HB or 2H. Add crosshair lines to determine which direction she's facing. Sketch in triangles for her ears and big loops for her hair (which you'll draw as balls of yarn). Draw everything very lightly, as you'll be erasing it at a later step.

STEP 2: Still using your hard lead pencil to achieve light lines, loosely draw more of her features. Use circles for her eyes and make a mark just a little distance below the crosshairs to indicate her nose.

STEP 3: Let's start working on the hair. Using a softer lead, such as a 2B or 3B, begin at the base of the bangs and pull your hand up quickly going from hard pressure to no pressure. It will make your line thinner and lighter at the top so that it'll blend into the white area of the hair on the top of her head. Switch direction when you move from the bangs to the longer strands of hair so that the longer strands are wispier at the bottom. It's okay to draw over the same lines; I do it to darken certain areas.

STEP 4: Focus on the balls of yarn attached to her hair. Working from the base of each ball, use a soft 3B lead and, instead of using a solid line, draw the strands with little jabs of your pencil, flicking your wrist with each stroke. Include a wayward strand to add a sense of movement to the drawing. Turning the paper while drawing a circular object really helps to maintain the shape and ease the stress on your wrist.

STEP 5: Draw the ears and collar (this will require that you erase your outline). Using a thin mechanical pencil like a 0.3 mm (or one with a super sharp tip) and little flicks of your wrist, add in the fur. It'll bunch up more in the center of the ear. With the collar, use firm pressure and try to draw it as one continuous line.

1

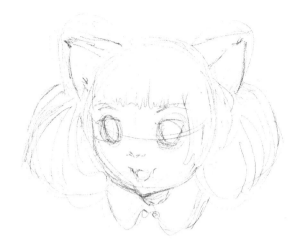

2

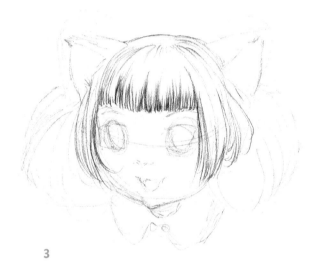

3

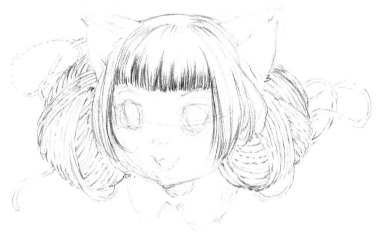

4

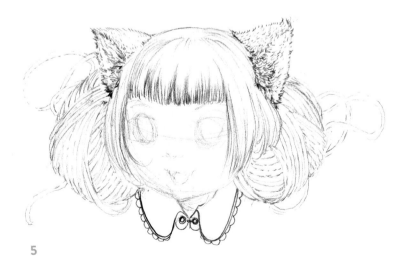

5

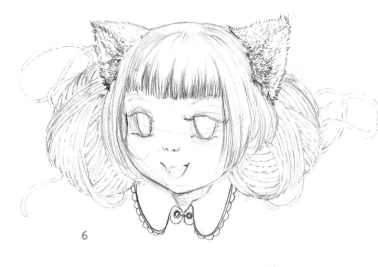

6

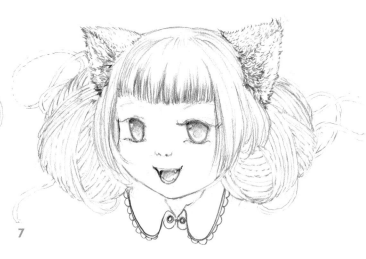

7

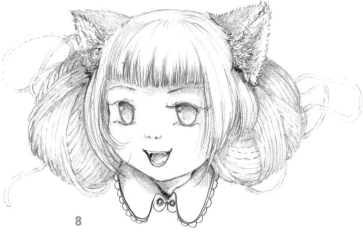

8

9

STEP 6: Let's move on to the face! Start adding the eyes. I like to begin at the tops of the eyes and focus on the eyelashes to provide shape. Once you draw in the top eyelashes, add the rest of her circular eyes and the bottom eyelashes. From there, add darker lines to indicate her nostrils. Moving further still, darken the lines of her mouth, focusing on the corners first. Then with short, light strokes, gently define the face, starting from the top of her cheeks down to the point of her chin.

STEP 7: Erase all of the underdrawing. Use a soft lead, preferably a 3B, and start filling in the eyes. Begin at the top, turn your pencil at an angle, and carefully shade in the iris. Start with firm pressure

and then lighten it, pulling your pencil away from the page. Repeat this action as often as needed to fill in the eye. Focus on making the top of the iris darker than the bottom. Draw in little fangs and repeat the dark-to-light approach for shading her tongue.

STEP 8: Here comes the fun part! I love adding the details. Using your soft 3B lead, carefully add shadow to the drawing by gently rubbing your pencil to darken the shadowed areas.

STEP 9: Continue using softer leads (from 2B to 6B) and sharp points on your pencils to fill in dark parts of the drawing. In the example, I focus on the yarn and make little dashes on the lines to show some texture.

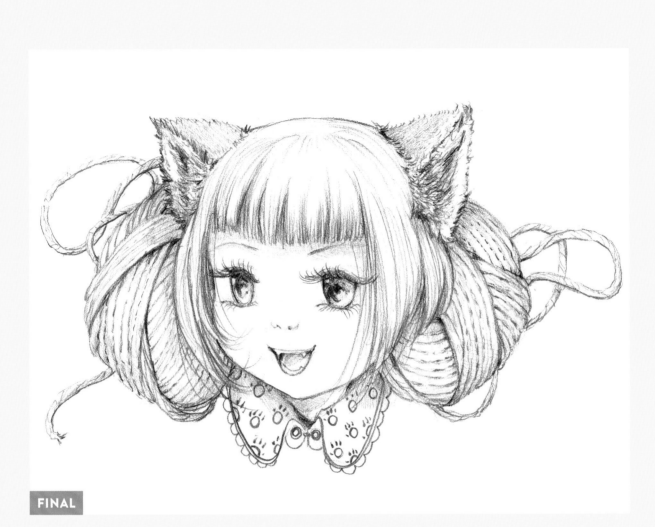

FINAL

FINISHING UP: Add minor details like the pupils, and you are all done! There are a lot of details to go over with this drawing. Take your time adding them until you achieve the level of completion that you are most happy with!

Vampire Bad Boy and His Beasties

Manga characters come in all types, from schoolgirls to giant space-fighting robots. Then, of course, there are the supernatural baddies! Let's take my favorite creature of the night and give it a Pop Surrealism twist! Because this is surreal art, you don't have to draw all the parts of the body. You can pick and choose the parts you want to use to assemble a unique portrait.

STEP 1: Using a midrange lead like an HB, B, or F, start with a circle for the head and add crosshairs indicating which direction the character will face.

STEP 2: Define more of the features by adding geometric shapes to your underdrawing. You'll notice that I added two bats and got rid of his cape! For the face, follow your crosshair lines. Add the mouth and nose to the vertical line, and the eyes to the horizontal one. Keep a relatively equal space between the eyes and the nose to maintain proportions.

STEP 3: It's time to tighten up your underdrawing. Start at the top and work your way down. Draw in the hair with steady swooshes. Be confident with your strokes and flick your wrist to get nice sharp points at the tips. Fill in more of the bats, adding in big eyes and round bellies to make them look more mangalike.

STEP 4: Erase your underdrawing. Use your mechanical eraser to get into the narrow areas. You'll also redefine some of the lines while you do this to maintain the integrity of the drawing, especially around the fingers and bow.

STEP 5: Focus on one element at a time. I chose to render his face here. Shading is super important for the eyes and the mouth. Always move from top to bottom, going from dark to light with firm pressure to light pressure, in order to get a smooth gradient. Make sure to define your edges with dark lines. Apply the same techniques to the bats' faces.

STEP 6: Speaking of the bats, let's focus on them next. They need to be fluffy, so use your eraser and rub out a little bit of their body line work. Now use a very sharp HB pencil or thin mechanical pencil like a 0.3 mm to draw in the fur. Use short quick lines. Now is a good time to fill in the wings' texture. Crosshatch in a few areas to add a lot of depth to these little critters.

Remember: The bigger the eyes, the younger the character will appear!

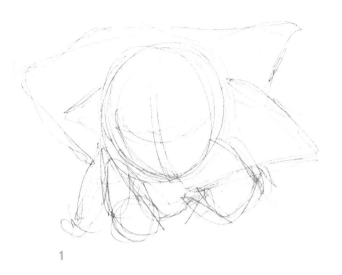

1

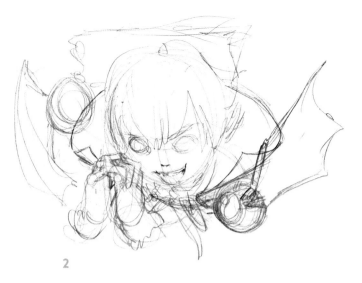

2

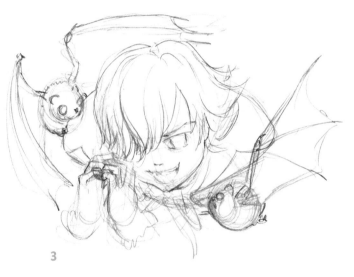

3

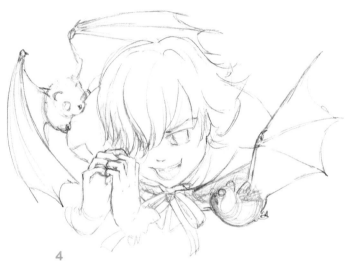

4

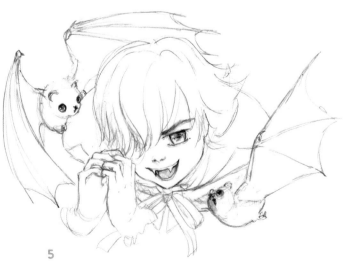

5

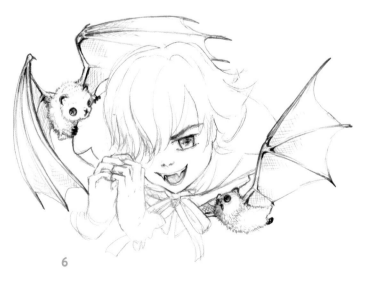

6

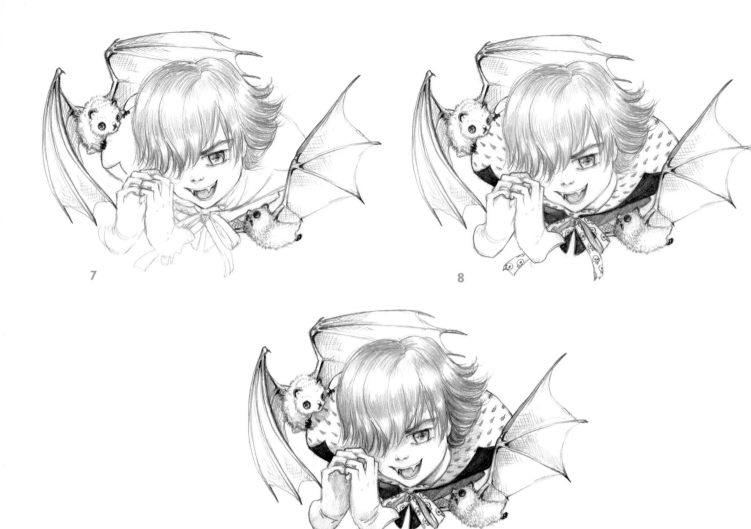

7

8

9

STEP 7: It's time to draw the vampire boy's hair! Giving this baddie dark hair requires using a soft 3B lead or a thick (0.7 mm or 0.9 mm) mechanical pencil. Dark hair in manga is always super shiny, so pencil in the highlights of the boy's hair. Generally, the shiny parts, the highlights, are at the top of the hair and near the tips. Layering is key here. Start with smooth, gentle strokes moving from his part and pulling down. Follow the contour of the hair and make sure to turn your paper as you draw to help keep the flow consistent.

STEP 8: Next, refine the details of his clothing. Add solid blacks to certain parts of the outfit. Doing so will provide balance with the geometric pattern that you'll add inside his collar. Including simple patterns creates a fun dynamic. The kind of pattern you choose can really boost the surreal level of your piece!

STEP 9: Add shadows and darken the hair. Use a hard 2H or 3H lead and apply light pressure to gently darken the areas that would cast a shadow. To darken the hair, repeat the drawing process over and over until you achieve the level of darkness that you want! Clean up any extra little bits of underdrawing to tighten the whole thing up!

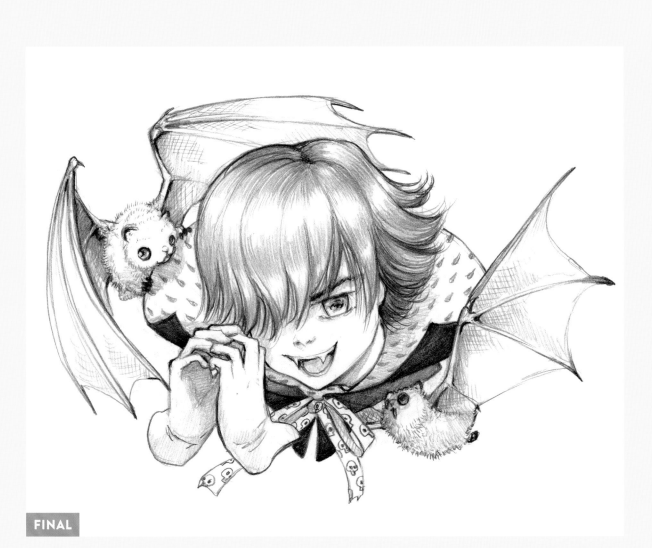

FINAL

FINISHING UP: Voilà! You are done! Try this lesson with a girl vampire and maybe add some mousey friends. The possibilities stretch out as far as your imagination can go!

A Leopard Can Change Its Spots

Adding a pattern to a drawing can really enhance its overall look and sense of dimension. There are so many patterns in the world—I could fill a whole book with them! For this lesson, let's embellish a drawing with a leopard-print pattern. Since we want to focus on the pattern for this lesson, you'll need to start with a nearly finished drawing that has some blank areas available to add pattern to.

STEP 1: Draw a character similar to the one shown here, using your skills from the beginner lessons. You can use the Meowzers lesson (page 80) for guidance on drawing a cat girl, and the Fluffy Fuzzbutts lesson (page 26), or the following Short and Sweet Fur Extravaganza (page 92), for help in creating a furry animal.

STEP 2: When drawing in your animal pattern, start with a hard 2H lead and lightly sketch in your pattern. Start at the top and work your way down. Follow the curve of your character's hair and wrap your leopard print pattern accordingly. Use short quick strokes. They don't have to be perfect. In fact, the scratchier your lines look the more they will resemble individual hairs. Don't put too many spots in one place—always place them randomly. Doing so will make them look more natural.

MANAGE YOUR MOOD

You might think that being an artist is all fun and games, but it's not. Sometimes it's really hard. The truth is that it takes a lot of work to be an artist. If you're like me, it's easy to get grumpy when you don't have an outlet for your creativity. If I don't draw at least once a day, I get moodier than a wet cat. Always take some time, even fifteen minutes each day, to doodle and draw and release that tension you're feeling.

Here's a tip for drawing fur! Fur can't just stick up in one direction on a critter. It covers an entire surface that has curves and bumps. To conform to the object's shape, slowly slope your fur.

1

2

3

4

STEP 3: Tighten up the pattern. Add a few more leopard spots to the areas where the hair bunches. Darken the spots at the edges of the hair.

STEP 4: It's time to tie all the details together. Add some of the pattern to the cat and to the girl's cat ears so that they appear similar. When adding spots to fur, use short strokes that spike up rather than using the curving lines employed for long hair. These shorter strokes provide a fluffy look to your spots. I used a softer 3B lead here to make the spots on the fur appear darker and to provide a nice balance to the light spots in the girl's hair.

FINISHING UP: (Opposite page) Add your shadows. Go over some of the spots with more pressure, or switch to an even softer 4B lead so that you can darken the spots at the places where there is less light. And, voilà, you've now added leopard spots to your character!

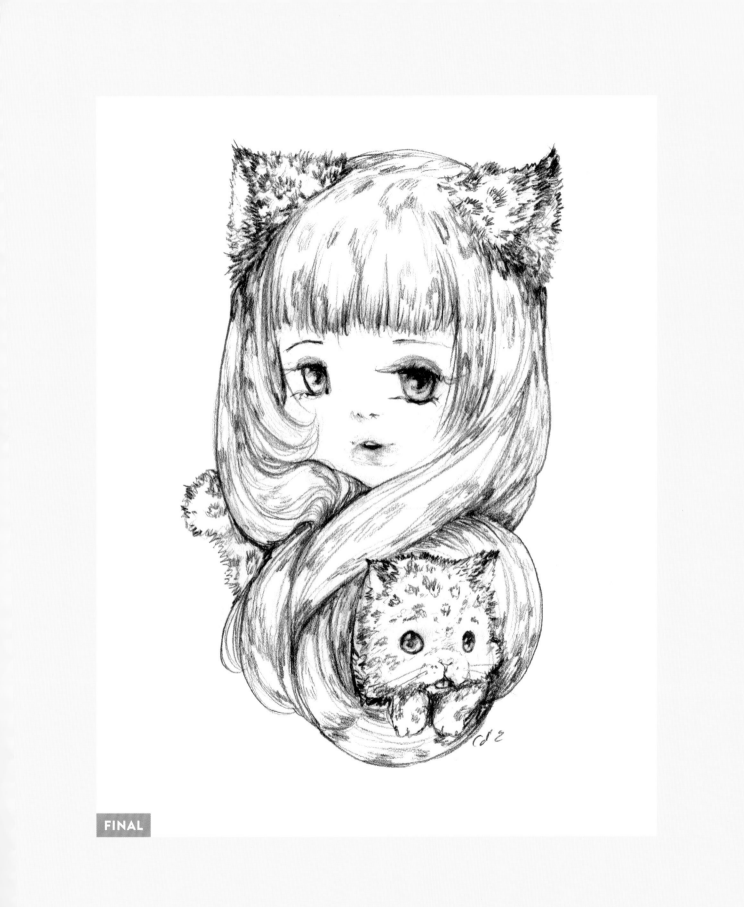

FINAL

Short and Sweet Fur Extravaganza

Drawing short fur is a great way to practice adding texture to your drawings. It can open you up to the possibilities of drawing lots of animals with spikey, fluffy, squishable fur. There are a few key techniques for drawing fur and hair, so let's take this lesson up a notch and show you how to draw both!

STEP 1: Shape out your characters. Define their forms very carefully by using minimal pressure with your pencil or using a light lead like an HB. You don't want to get too detailed here. Keep your outline general and don't add any fur yet.

STEP 2: Define the most solid areas of your characters, like the eyes, noses, and so on. Doing so is good for warming up your wrist. It also allows you to slowly establish the emotions in the piece before you move to the more mechanical, technical aspects of the drawing process. Fun fact: the closer a nose is to the eyes, the younger a character will look.

STEP 3: Now it's time to start drawing the fur. Following the path of your characters' shapes, add in uneven jagged lines to depict the fur. The lower into the wolf's neck you get, the longer its fur appears. Lengthen your lines accordingly.

STEP 4: Get your eraser out and start removing the underdrawing. Be very gentle. In fact, I like to dab my eraser lightly over the lines instead of rubbing it. It's okay if you remove some of the fur lines you drew because you'll be adding lots more soon! Make sure to clean your eraser on a scrap piece of paper after every few strokes. Your eraser can build up graphite that will eventually smear. A clean eraser equals a clean drawing!

Fluffy critters are the best! Make 'em super fluffy by adding fur everywhere like a fuzz ball!

1

2

3

4

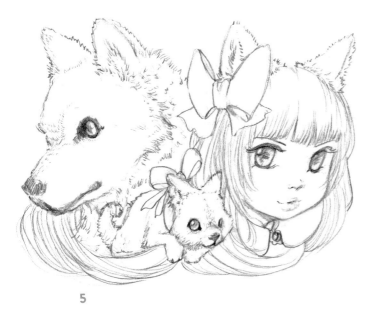

5

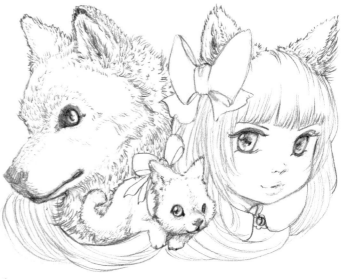

6

STEP 5: Think of adding short fur as almost being like *pointillism*. (That's a style of art where you use dots instead of strokes.) You don't want to get too carried away and fill in every little bit of the fur (unless the fur is dark), but do keep in mind that manga is a more simple, clean style of art than what you might see in realism. Focus on the edges of the fur first, and then build from there.

STEP 6: Continue to build up the fur as much as you want. Remember: A minimal approach is okay too. I like to get in there and define the difference between the ear fur, which is longer, and the forehead fur, which is shorter.

FINISHING UP: (Opposite page) The final step here is all about the little details. Make refinements to your drawing: Add more little wisps of fur where shadows are most likely to be, like under the chin or where the fur bunches. Take time to darken areas to help give a sense of dimension.

MAINTAIN FOCUS

In this day and age, it's hard to not let the world distract you. Our phones alone are one of the biggest causes of procrastination. With their quick access to social media, email, and so on, our electronic devices are like a shiny object to a magpie. Do yourself a favor and set aside the phone and laptop to focus purely on your art. Once you get into the zone, you'll see the focus come—and you'll produce better artwork faster!

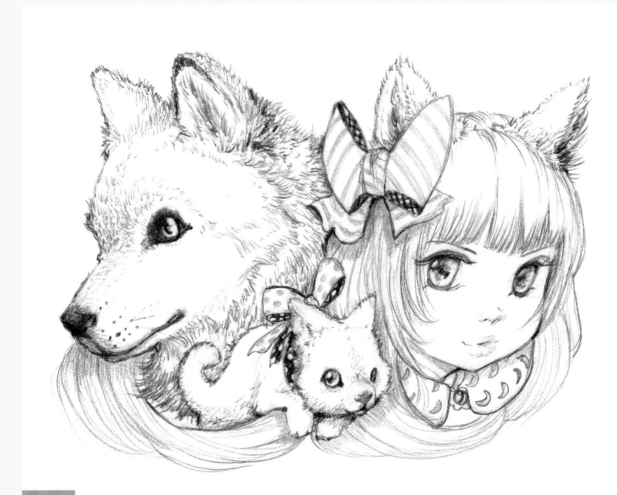

FINAL

The Lion Prince

Long fur is a different beast altogether than short fur. For this lesson I'll teach you how to draw long fur and medium-length human hair! Two for one, baby! The techniques are essentially the same. Lions are a great example of long fur and a manga boy is perfect for medium-length hair, so let's begin!

You can draw the eyes in whatever way you like! They are the windows to your artistic soul, after all! Draw them with or without pupils, big or small, circular or oval, it's up to you!

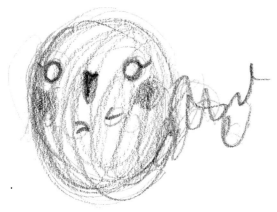

STEP 1: Establish your characters using an HB or B pencil. This time, since you're drawing long fur, you need to think of its placement as part of the character. Long fur flows, so pick a direction in which it will go and use wispy lines to chunk it in. The mane sits on top of the boy's head, so be mindful of how the mane will connect with the surface of his hair. You want it to flow nicely.

STEP 2: This step is all about capturing the emotion of the character and drawing in the solid areas. Lions have very striking eyes and lip lines, so use a softer 2B lead to fill in those parts. That way, you can shift the pressure and get darker lines easily. You can also switch pressure to lighten the lines at the points where you will add more of the fur shape.

STEP 3: Here, the long fur should gradually go from shorter at the top to longer near the bottom. Fur differs from short hair because it tends to go in multiple directions. Fur has more layers, which gives it a fluffy look. For long fur, it's good to start at the root, or top, and then work your way down. It's also okay to use your eraser whenever you want to make a change.

STEP 4: Using your eraser, carefully remove as much of the underdrawing as you can. Once that's out of the way, you can focus on adding more lines to fill in the fur. Use slow, steady strokes with your eraser. Take your time. There's no rush. Remember not to use your hand to wipe off bits of eraser. The oil on your skin can easily smudge the drawing. Use a little brush or your shirt sleeve (but lightly!), or just blow away the shreds.

1

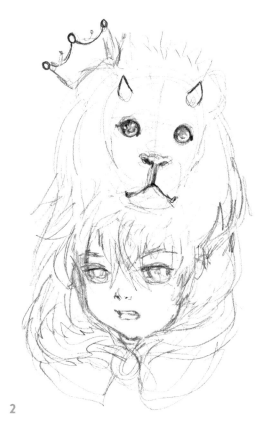

2

3

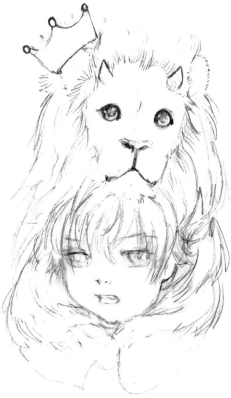

4

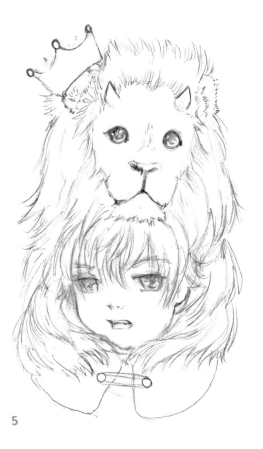

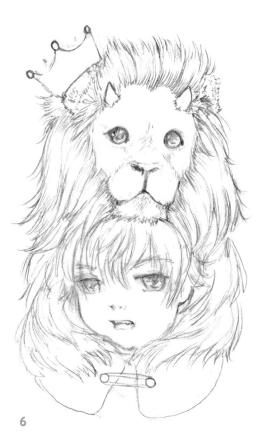

5

6

STEP 5: Draw the outline of the fur. Doing so determines how long the sections are, and you can then work backward from outside to inside. It helps you keep things cleaner and more structured.

STEP 6: It's time to add some fine lines! For long fur, you can switch from pencil to pencil to get the right line work. The tips and edges where the fur bunches should be darker and the lines of the fur should be lighter. Harder lead pencils like an H (and up to a 3H) will do the trick, or you can use a smaller mechanical pencil like a 0.3 mm.

FINISHING UP: (Opposite page) In the final step, focus on adding more thin lines at the edges and where the fur connects to body parts like the ears and eyes. It's totally normal to have to go over lines at this step, so don't think that you can only do one line and that's it. I constantly draw over my lines to build up areas, making them darker and further defining them.

BE PREPARED

Always carry a sketchbook! Inspiration can strike at any time, so you don't want to be caught in the moment of inspiration with nothing to draw on. Your cell phone is an excellent tool to record your inspired ideas. Use it to type your idea into a notes app.

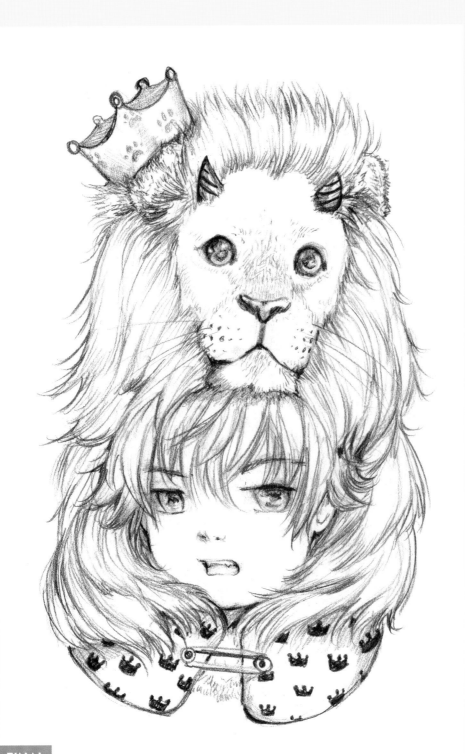

FINAL

Angelina

I love angels. They are so beautiful and ethereal, but also surreal! Let's take the world of angels and give it a Pop Manga surrealist twist! This drawing is all about fun twists of reality, so you'll depict this angel with a cloud umbrella that has paper lightning bolts hanging from it!

STEP 1: When drawing a full-figure character piece, the steps are pretty much similar to the ones you've seen in previous lessons. Using a midrange lead, like an HB, B, or F, start with the circle for a head, and then draw lines like you're drawing a stick figure. Use circles for the joints and for the hands and feet.

STEP 2: Add some definition to her body. Always draw in the body first and then add the clothing afterward. This approach is necessary to make sure that your proportions are correct.

STEP 3: It's time to add more details, such as her clothing, wings, and the cloud umbrella. Keep movement in mind as you work. I like to pretend that there is wind in the scene, blowing the various elements around.

STEP 4: Add simple shapes to define the outline of the character and the other design elements. Because there are so many elements, you'll want to spend a whole step getting them all right. It's okay to have parts of the character overlapping with others.

STEP 5: Darken your outlines and contours. You want to have a solid look to your drawing. At this stage, you can add in more details, like the folds of her clothing and hair wisps.

STEP 6: Erase the underdrawing. Now you can change, redraw, and correct parts, since you will have removed the excess lines and can determine what more or what little needs to change moving forward in the drawing process.

Legs are always longer than arms, forearms are shorter than upper arms, and thighs are longer than shins.

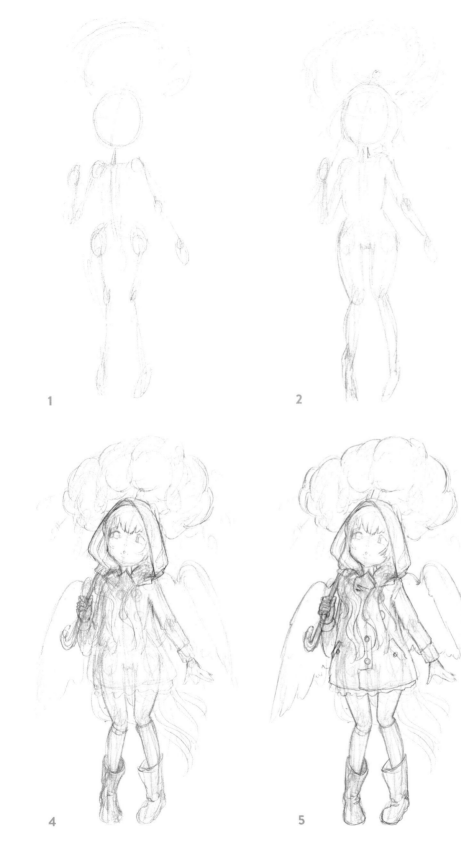

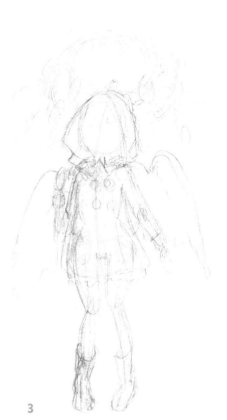

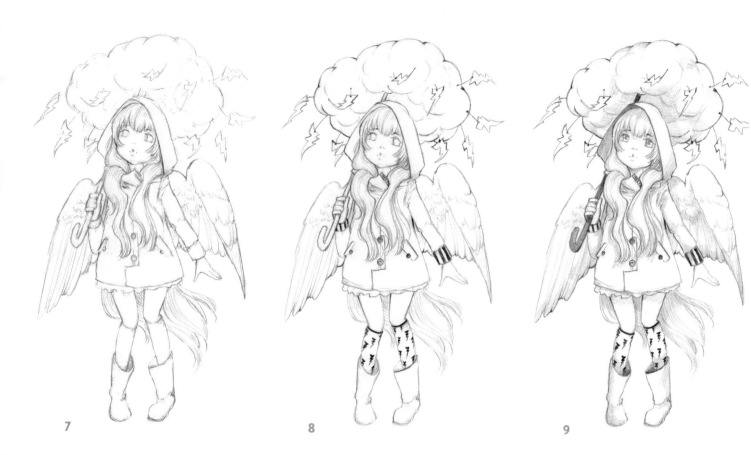

7 8 9

STEP 7: Now it's time to refine and add details! Remember: Less is more. You don't have to draw every feather and every strand of hair. Choose areas to focus on. Use a thin mechanical pencil, either a 0.3 or 0.5 mm, to create these details. Use light-to-firm pressure to make the lines that go from light to dark.

STEP 8: Switch to a softer 3B lead and fill in little details to flesh out your drawing. Always start with light strokes and then move to firmer ones.

STEP 9: Shade in your drawing! Start with light shading, and then go over it again with another layer. When shading, I like to hold my pencil near its end (by the eraser) at a low angle, positioning it close to the paper. Doing so helps prevent me from accidentally pressing too hard at one point.

FINISHING UP: (Opposite page) Finalize your drawing by filling in darker areas with shadows. I use a glitter marker to color the lightning bolts. You can use paint or markers for this part—it's up to you, baby! There you have it. You've just drawn a very surreal angel girl with a cloud umbrella!

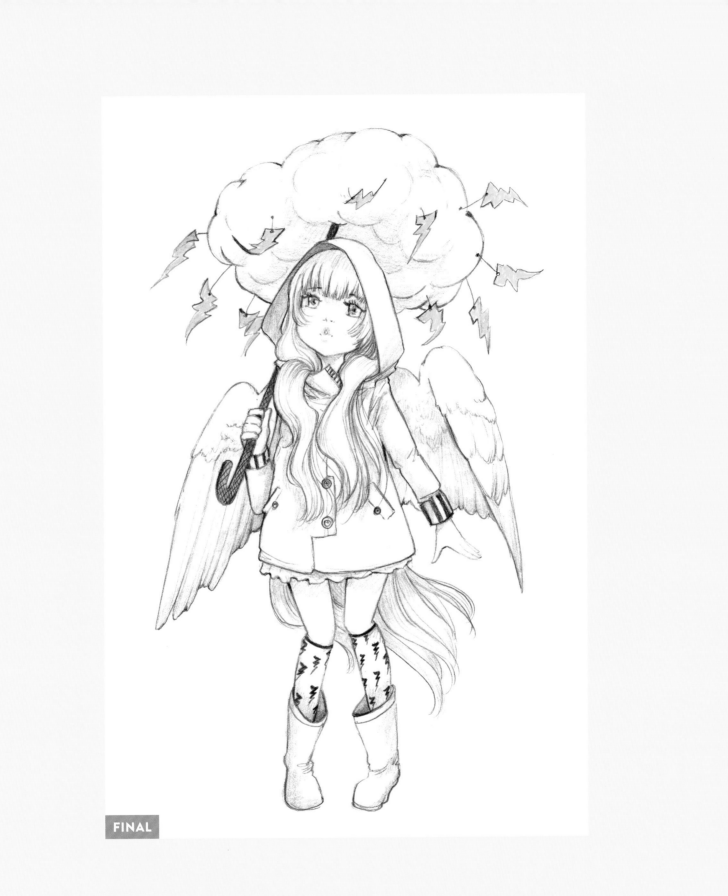

FINAL

Making Undersea Friends

There's nothing more surreal than a half-human, half-fish person. That's right, I'm talking about mermaids! Because I love mer-people so much, I couldn't resist adding a lesson on drawing a mermaid. There's so much movement involved in drawing these magical creatures. They have flowing hair and tails. Keep movement in mind as you draw. It's all about the flow!

Layering elements in your drawing gives it a dynamic look, so make sure to position some elements behind and in front of others.

STEP 1: When drawing a mermaid, it's important to establish the flow of the character first. Using a midrange pencil lead (an HB, B, or F), start with her head: draw a circle. Then draw a line that will essentially serve as her backbone. Give it a swirl toward the bottom of the page. This line provides a natural fluid motion for your character.

STEP 2: Using simple lines, add the body and tail. Consider the tail and how it will flow just like her hair. Loosen your grip and just let the pencil glide over your paper. It's okay if it looks messy. Messy is good. It allows you to establish a natural flow to your drawing.

STEP 3: It's time to refine your drawing. Add elements like the mermaid's facial expression, her fins, and the expressions of the fish. Keep your lines light—don't apply too much pressure. Most of your line work is going to be erased in the next step!

STEP 4: Once you have the basic outline or underdrawing, switch to a softer lead like a 3B or a 2B. Using darker lines, trace over your underdrawing to establish the outline of your character.

STEP 5: It's time to erase! Switch between large erasers and small ones in order to remove all of your underdrawing. Take your time and redraw any needed parts that you accidentally erase.

STEP 6: Tighten up the outlines. I like to trace over the lines and thicken up certain areas. Doing so adds dimension.

1

2

3

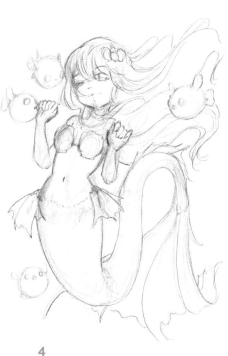

4

5

6

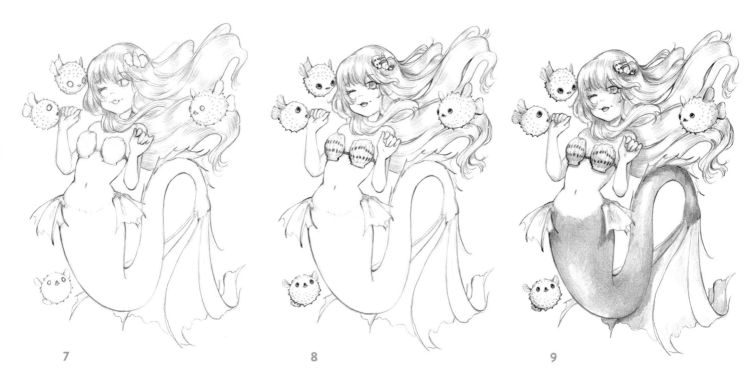

7 8 9

STEP 7: Add details to her hair. Use a pencil with a fine tip. Add hair strands to the parts of the hair that rolls over top of the other hair, but leave the top of the hair waves with less definition. Doing so gives you the appearance of shiny hair. Work with quick strokes to achieve a cohesive look.

STEP 8: Focus on filling in the details. I like to switch from hard leads to soft leads so that I can get lighter and darker lines.

STEP 9: Time to shade! When shading the tail, contour it with darker shadows near the edges of the tail and lighter shading in the center.

FINISHING UP: (Opposite page) For the final step, add further details and thicken your line work. Now you are done and have created a cute mermaid with adorable puffer buddies!

GRAIN OF SALT

Take people's opinions with a grain of salt. You'll come across lots of people who will give you unsolicited advice, or who will try to make you change things in your art. Remember that it's your art and your expression. As long as you are true to yourself and create your own original content, you can let the rest of the world do its own thing while you do yours.

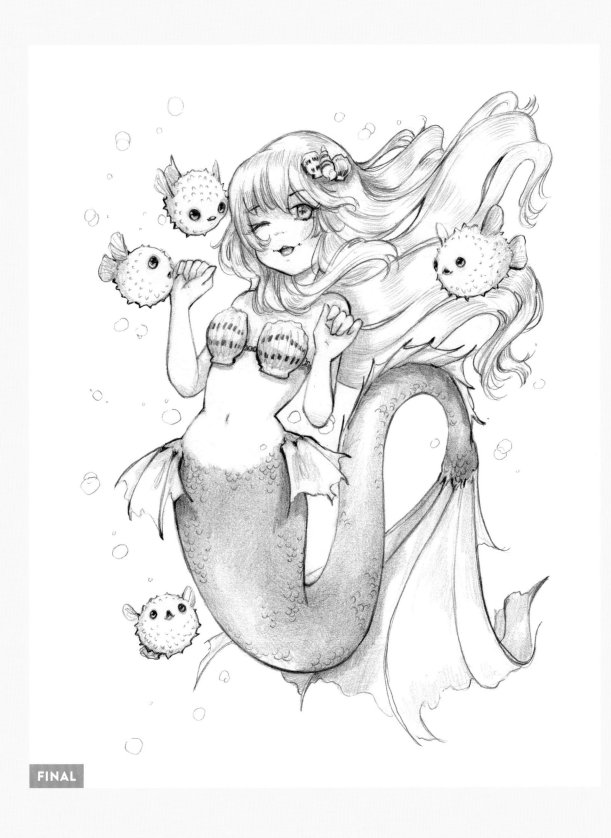

FINAL

Baa Baa Black Sheep

There are many different kinds of animals in the world. There are also huge assortments of hair types. So what would happen if you took sheep's wool and put it on a person's head? What would happen if we turned a girl into a half-longhorn sheep? Well, you are about to find out!

Try to avoid sharp edges and go for rounder ones, in order to give your drawing more natural, softer contours like me, baby!

STEP 1: Using an HB pencil, start at the head and work your way down. Because this pose is from the back, you won't have to draw her right arm. However, it's important that you establish her hips and pop them up a tad to provide a sense of extra movement.

STEP 2: Fill in her body with light line work. Use your previous lines as the skeleton. Here's a trick for the legs: draw the roundness of her buttocks then move your line down. It's important to understand anatomy so that you know what parts connect with others. Be sure to add a fluffy sheep buddy using pale strokes.

STEP 3: Okay, let's add some clothing and this character's expression. I want her to appear super excited, so let's give her a big, wide smile! With the clothing, make sure that you include folds and creases to simulate real clothing.

STEP 4: Refine your drawing, but do not fill in the hair. That has its own special step ahead! Instead, contour the horns. You will layer the hair over the horns next.

STEP 5: Time to get your 'fro on! Use a soft B or 2B lead so that the lines you make will appear dark. I like to draw sheep wool by making tiny little spirals over and over again. Start at the girl's forehead and work around her face. Do the same for her sheep! Spiral the hair tightly, and then swish it outward for each little strand.

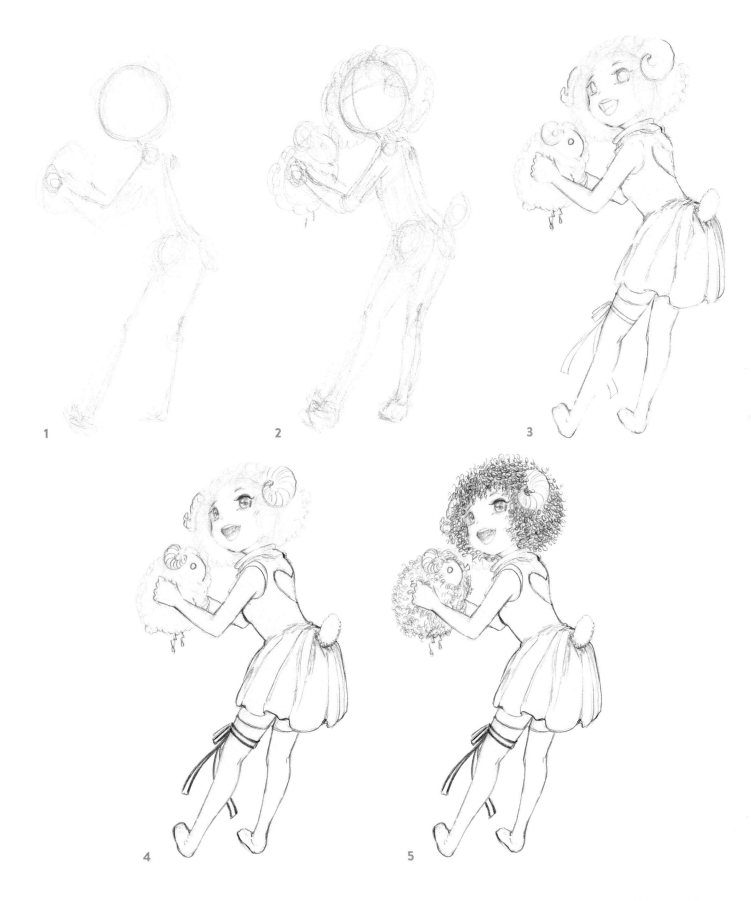

1

2

3

4

5

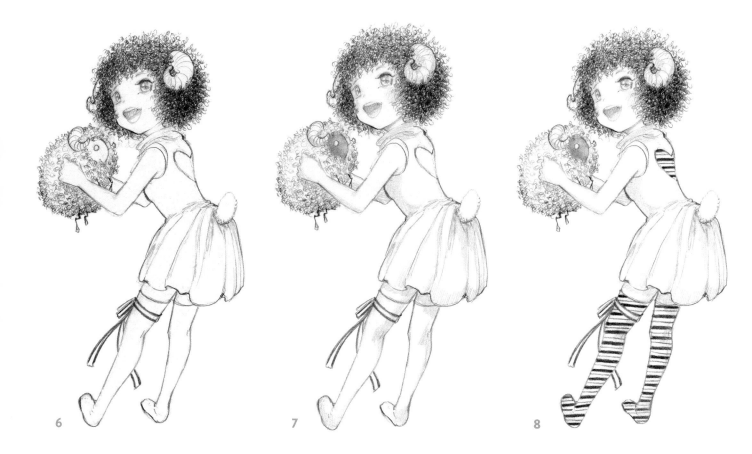

STEP 6: Continue working on the curly hair, adding darker patches where the shadows would fall. Rather than shade it, draw more spirals over existing curls.

STEP 7: Now you can shade! Switch to a light H lead or a thicker mechanical pencil lead, to fill in the shadows.

STEP 8: Add some patterns to her outfit to make your design more interesting. One surreal way to do this is to ignore the three-dimensional aspect of your character and just draw the pattern flatly.

FINISHING UP: (Opposite page) Complete the drawing by adding more shadows and refining your lines.

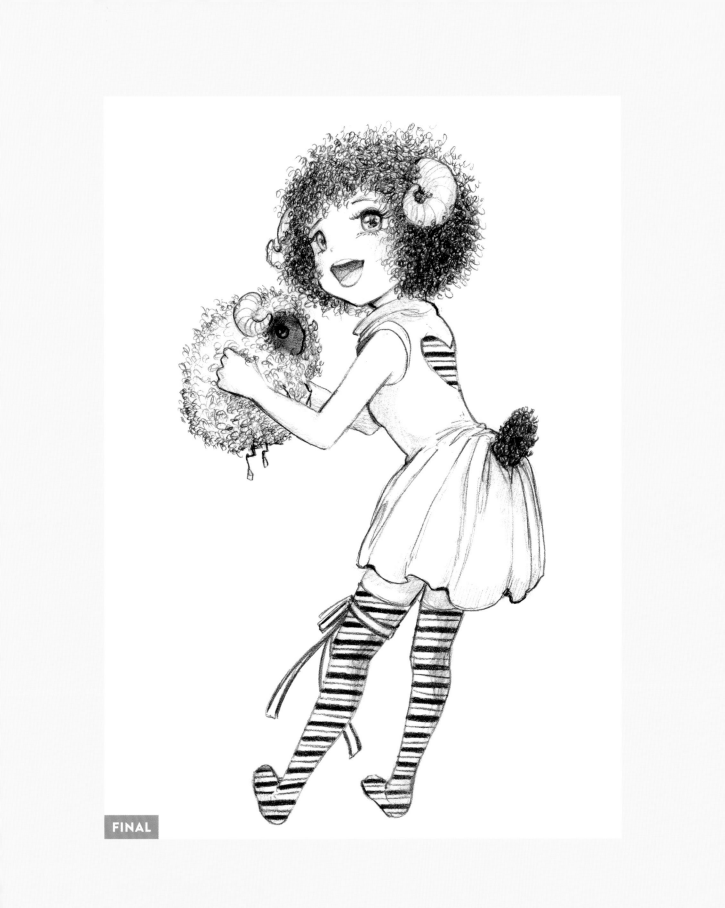

FINAL

Puff and Fluffs

Who loves dragons? I do! I do! Dragons are so fierce, magical, and amazing. In true manga style, I want to morph this dragon into a boy! Let's twist reality further by drawing a half-dragon half-boy along with his adorable little buddies! In this lesson, I'll show you how to blend two creatures into one while also demonstrating motion and fluidity.

To keep your line work loose, shake your hands first, and then confidently create a continuous line from the back of the boy down. Then flick your line back up.

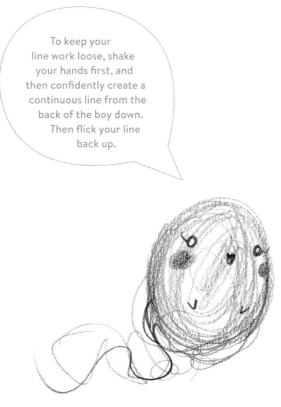

STEP 1: When drawing a character with swagger, you've got to exaggerate the body language. With a lighter HB lead or a 0.5 mechanical pencil, use a skeleton-like stick figure to create the outline for your boy. Have his hips jut out slightly and have his face turned to the back. Then, add in a swirl for his tail.

STEP 2: With boys, you don't have to worry about the curves as you do with girls, so box in the elements of his outfit and fill in the tail. Add a circle shape for one of the little critters. Start blocking in the wings as well.

STEP 3: Focus on clothing and character features. Spend some time on this part. There's no rush! Make sure to include wrinkles in the clothing and to add interesting features, like more pets and messy hair. Don't forget the horns!

STEP 4: Time to refine! Switch to a pencil that has a soft lead, preferably a 3B, or to a 0.7 mechanical pencil with a sharp point. Use firmer strokes to outline your characters. Remember that this is pencil drawing, so if you make a mistake, erase and redraw!

STEP 5: Erase the underdrawing as best you can. I like to switch from big erasers to using the mechanical pencil eraser in order to get as much of that underdrawing off of my paper as possible.

STEP 6: Contour your drawing. I like to add lots of creases to the clothing to give it a more natural look. Use a pencil that is at least a 2B to achieve these lines.

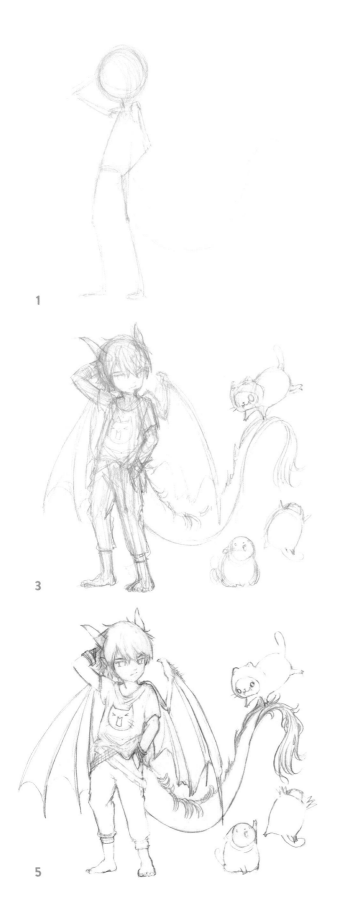

1

3

5

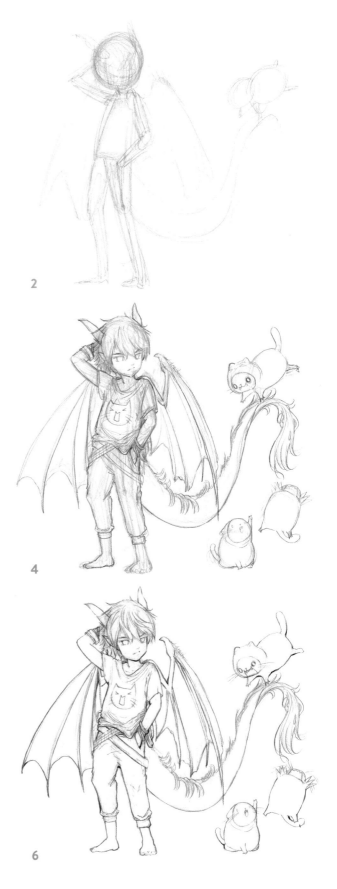

2

4

6

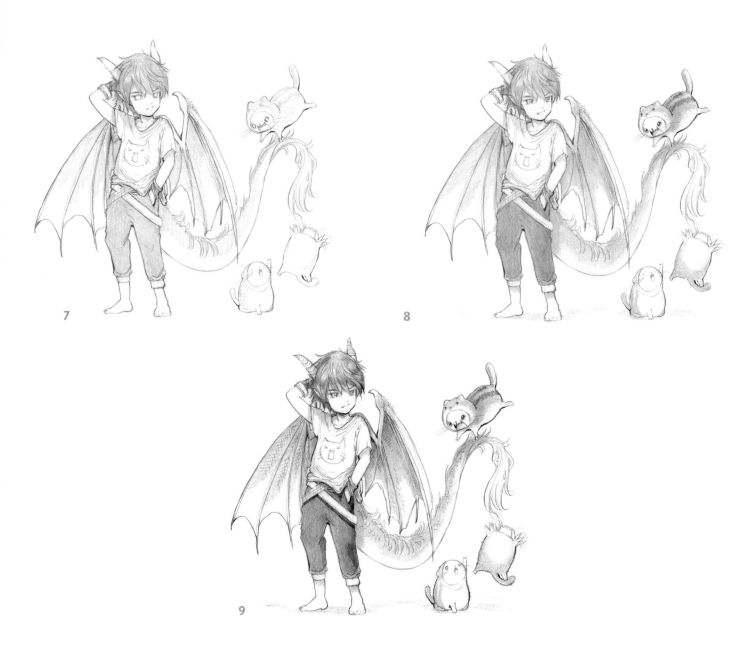

STEP 7: Now switch things up and shade! You want to shade in order to give this character darker hair and clothing.

STEP 8: Finish up the shading. Generally, shading takes the longest because you have to put down many layers. You should also add shadows. This way you give the piece as much three dimensionality as possible.

STEP 9: Fill in character details. Add cross-hatching to the wings to show some texture. The same goes for the kitties. A few lines of texture go a long way to making your drawing more interesting!

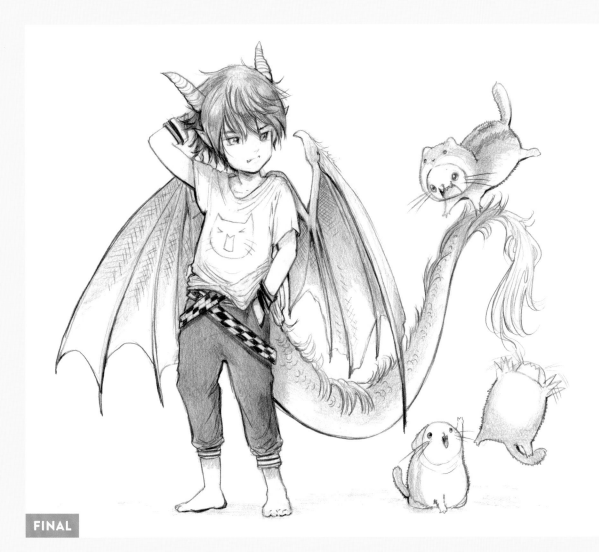

FINAL

FINISHING UP: For the final stage, thicken some of the lines and refine your contours.

Frog Princess

The adorable outfits that your characters get to wear are some of the cutest things in manga. For this lesson, I'm taking my love of frogs and putting it into the world of Pop Manga fashion! You're going to take a girl in a frog outfit and depict her riding on top of a frog. You can imagine her as tiny or the frog as gigantic. It's up to you! That's the beauty of art, it's so subjective. Let's get hopping!

Use photo reference, if you need help with the frog's proportions.

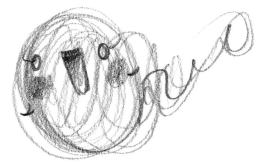

STEP 1: This pose requires you to draw two figures. Using a midrange lead (HB) or a 0.5 mechanical pencil, start with the frog, since the girl will be placed on top of it. Draw your frog near the bottom right of your paper to give plenty of room for the girl. Use simple shapes, and keep in mind that this is manga. That means you can exaggerate the frog's head and body. I decided to go with a super chubby frog!

STEP 2: Fill out the frog's body with loose line work. Keep your lines super light, since you'll place the girl on top of the frog later. You don't want your lines to be too dark or you won't be able to see the girl.

STEP 3: Add the girl. It's best to include her before you fill in any details on the frog, since she'll cover up most of its back. Start by drawing the shape of her head and then use lines to represent her skeleton. Think of it like drawing a stick figure, with circles included for joints, hands, and feet.

STEP 4: Refine your characters. Add body mass to the girl. Keep her body proportions accurate, even though you're covering her up with clothing.

STEP 5: Fill in the details of her clothing. I thought it would be cute for her to wear a frog hoodie and fun socks. Exaggerate the proportions of the clothing to give your image a more manga feel. (The clothing in manga is usually much larger than the character when the artist's intention is to make the character appear cute. The bigger the clothing, the cuter the look.)

STEP 6: Outline both characters by using a softer lead like a 3B or 4B or by adding more pressure to your pencil strokes. It's time to erase those messy strokes inside your figures. Use a soft eraser to remove parts of the underdrawing and a clean dry paintbrush to wipe away the little bits of debris.

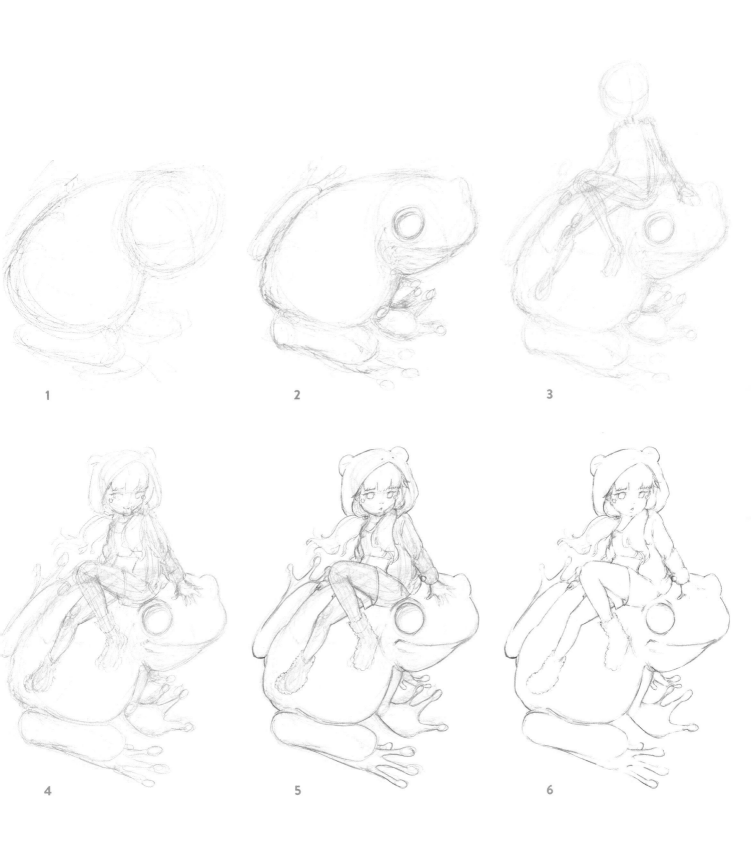

1

2

3

4

5

6

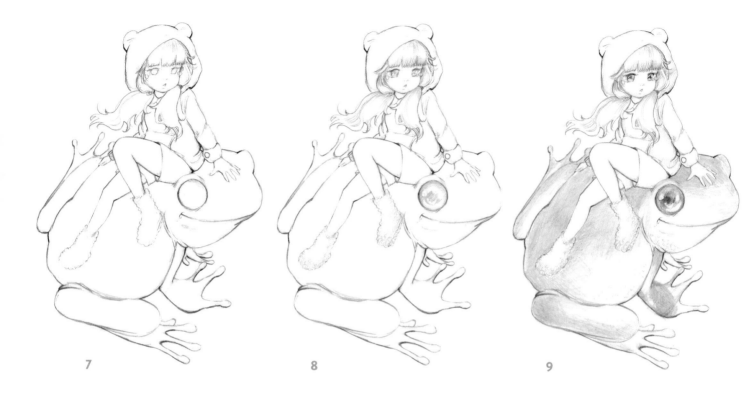

7 8 9

STEP 7: Add depth to your outline by going over the lines with your pencil and darkening them. Don't press too hard or you'll snap the tip! Keep a steady hand when outlining. Try to use fewer strokes and more continuous ones.

STEP 8: Refine the lines and tighten up your drawing. Use a soft 5B lead to create darker lines. I always make sure to have a super sharp pencil ready for this stage or I'll switch to a 0.7 mechanical pencil. Carefully fill in any lines that were erased and also thicken up lines on the underside of your characters. Doing so helps to ground them in the drawing.

STEP 9: Slowly fill in more details. Build up layers one at a time. I recommend using a hard lead (like an F) to start the shading. Shade in your characters carefully, using many layers. Switch pressure from light to hard as you darken. Remember to turn your paper to switch the angle at which you shade. Doing so provides an even look to your shading.

FINISHING UP: (Opposite page) Using your softest lead (like a 4B), add the finest details and fill out the edges and contours. I like to go over the shadows with this pencil after I've done my initial shading so that it creates a darker area. Now you are all done, lovelies!

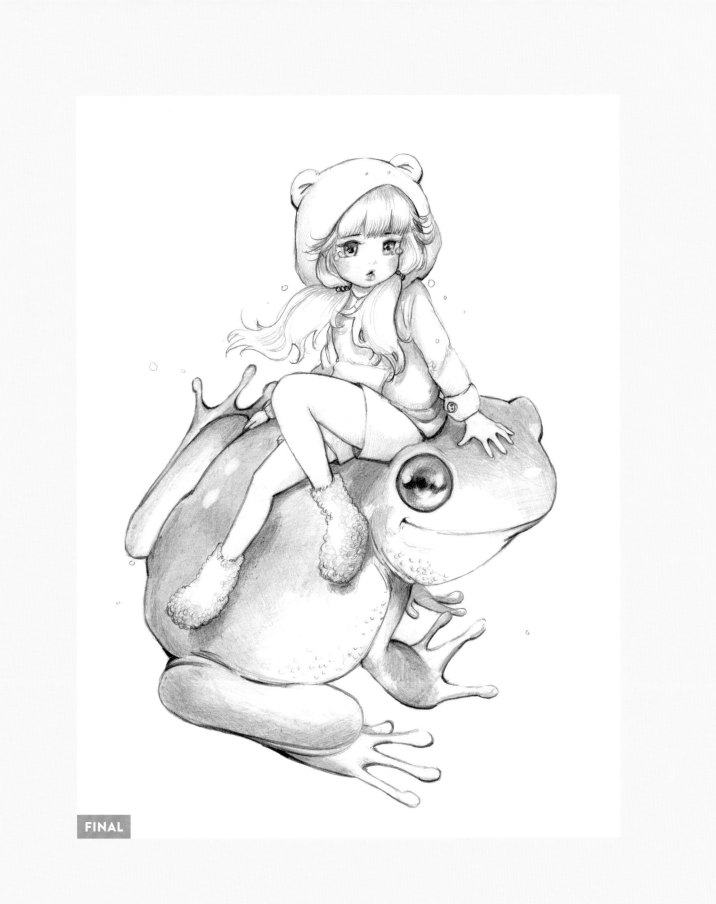

FINAL

Hearts Abound

Another way to show off your surrealist style is to take things that are impossible and make them possible by using a theme. I'm a hopeless romantic, so I love hearts and other objects of love. For this lesson, I want to take that love to the next level through portraiture! So, let's give this girl heart-shaped glasses, heart-shaped hair buns, and even a heart-shaped torso! Bring on the love!

The more you hesitate, the stiffer the drawing. Just go for it! Draw your underdrawing wildly and freely. This does not have to be perfect, so let go of your reservations and draw!

STEP 1: Using simple shapes, sketch a light series of circles and hearts that will serve as the girl's head, hair, hand, and body. Use a thin mechanical pencil (0.3) or a hard pencil lead (like a 3H) so that your marks aren't dark and you can erase them easily if needed.

STEP 2: Fill in a few details like her eyes, mouth, and nose. You should also fill in a few details on her hand, but keep your marks light. Let's also keep the "love" theme going, and add heart-shaped eyeglasses. Try to keep both hearts the same size.

STEP 3: It's time to erase the underdrawing! Erasing as you go helps to keep a complicated drawing from getting messy and confusing, so gently remove any unnecessary lines here.

STEP 4: Draw the hand and glasses. Use a soft lead like a B. Use your eraser to get the lines right. Add more details on her face by using a softer lead like a 2B or 3B and gently drawing them in place. Start with the edges and work your way inward.

STEP 5: You're going to need lots of patience to draw her hair buns. Using a hard lead, an H or 2H, start at the top of the bun and use smooth lines to draw the hair from top to bottom. You can then change direction and go from bottom to top.

STEP 6: To start filling in her open eye, draw the top eyelid. Then add a small circle at the top of the left corner—that's your highlight. You can use the highlight to create a contour of the iris. Draw in the bottom eyelid, once you've drawn the iris. Fill in details for her fingers by erasing some of your underdrawing. With a soft lead, such as a 3B, change pressure from dark to light, as you draw in the details.

1

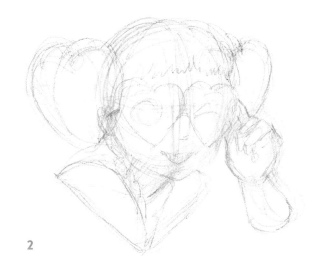

2

3

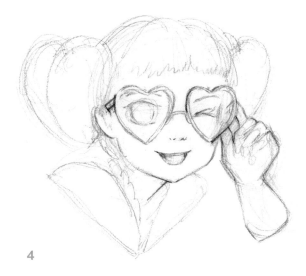

4

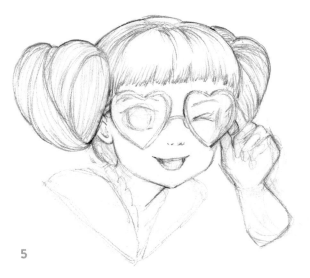

5

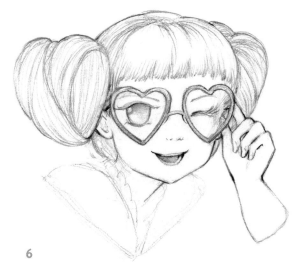

6

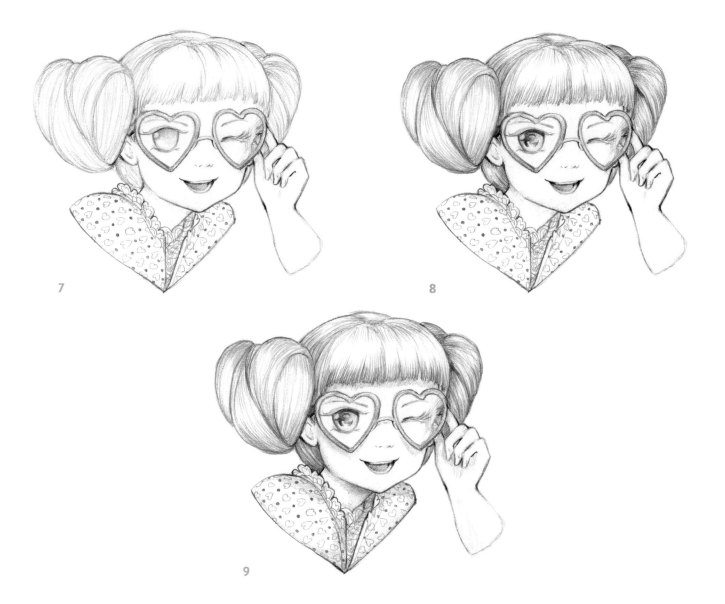

7

8

9

STEP 7: When drawing in her heart-shaped body and adding the clothing, use your imagination to select the pattern or lace that will match the theme. I opted for heart-themed lace. Draw in the outline and erase any extra line work. Switch to a thinner lead, such as 0.5 mm for a mechanical pencil or to a harder lead (2H) for a graphite pencil, and draw in your pattern.

STEP 8: Add more detail to her hair by using a thin 0.3 mm mechanical lead or a hard 3H lead graphite pencil. Go over what you've done with more lines. Darken the bottom and the top of the hair. Doing so creates a three-dimensional look. Add the pupil on the girl's eye. You can make it circular or draw it as a half-filled pupil.

STEP 9: Add shadows by using a hard 2H lead and shading in areas. Change your pressure from hard to gentle as you go from dark to light. Add a few lines on the glasses to indicate reflections. To include her eyelashes, you'll need a very sharp B lead pencil. Start at the eyelid and, with the flick of your wrist, draw in one lash with hard pressure, quickly releasing the line once you make the mark. I like to turn the page around so that it's vertical. This positioning makes it easier to create a curvy lash.

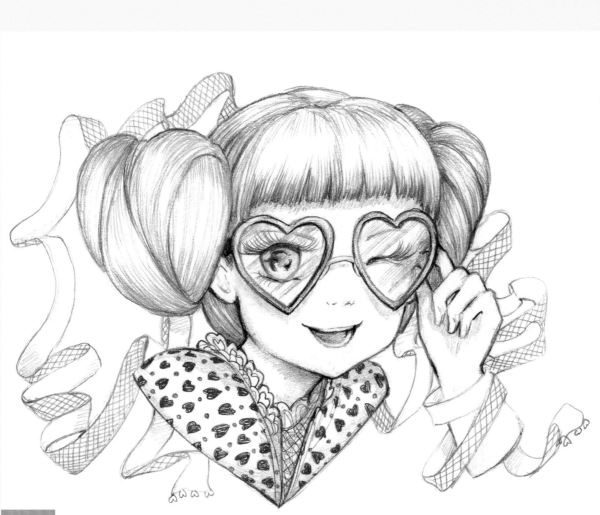

FINAL

FINISHING UP: Add pink to the pattern in her shirt and the rims of her glasses with markers. I used a pink Pigma Micron, but you can use any marker since the area you are adding the pattern to is light and won't smudge if you add marker to it.

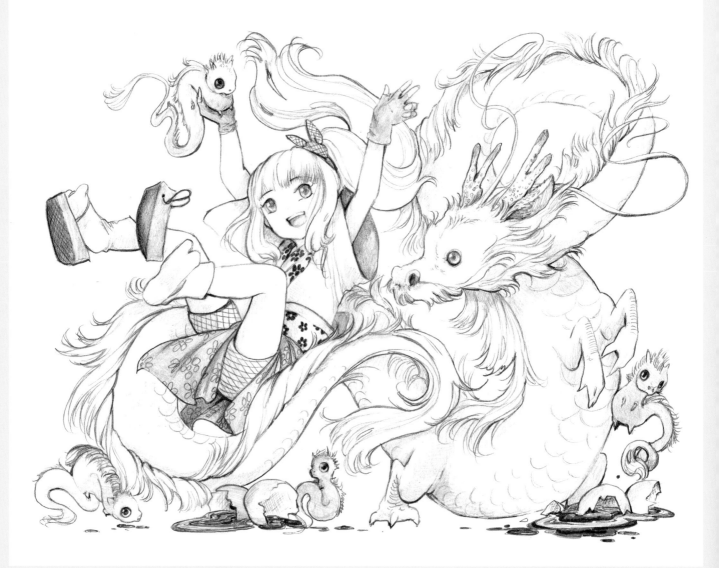

THREE

MASTER CLASS LESSONS

Are you ready to take the next step in drawing Pop Manga? You've run the gauntlet of beginner and intermediate lessons, so it's time to get your proverbial black belt in drawing! These five lessons expand what you know and push you to new heights of creativity. You'll focus more on movement and details in than the previous lessons. This is where you show the world that you can draw complex patterns and multiple characters interacting. This is where you become a master of Pop Manga!

Mad Honeycomb-atter

Adding geometric patterns is tricky especially when you're working with three-dimensional objects. So this lesson is more advanced than earlier ones! Honeycomb is a very difficult shape to draw repeatedly over objects. You'll want to add this pattern in such a way that it looks like the pattern follows the surface of your object. Doing so makes your drawing look three-dimensional. To achieve such an effect, you have to think about altering your shapes and lightening and squishing your pattern to fit your object. For this drawing, I'm going to add polka dots onto a ribbon and a honeycomb pattern to a hat and gloves. You'll need to start this lesson with a nearly finished character. You can either use your skills from the previous lessons to recreate the character shown here or choose another character that has blank space available to fill in with a pattern.

Use photo and image reference of the patterns you want to draw so that you can keep them consistent.

STEP 1: Using an HB and 3B graphite pencil or a 0.5mm mechanical pencil, draw in your character. Once you have your baseline drawing ready, it's time to add the patterns. You'll know you are ready to add patterns when the bulk of your drawing is done. Think of it as the icing on the cake!

STEP 2: Let's start with the polka dots because they're easier to draw. The secret to drawing polka dots? Draw them one row at a time. Think of them as your warm-up before you tackle the honeycomb. Start at the bottom of the edges of the bow and draw in half circles. By doing this, you imply that the pattern was cut off in the fabric. This feature adds realism to your drawing.

STEP 3: When drawing a pattern on curving fabric, reshape the dots so that they conform to the surface of your fabric. Some of your dots need to be "tilted" or "flattened." It's very important that your pattern flows along the ridges of the cloth. Otherwise your fabric won't look three-dimensional.

STEP 4: Once you complete the polka dots, it's time to add the honeycomb! This pattern is much trickier because its pieces are connected. But don't worry! Start slow and build up your pattern. I like to draw circles first. Then, once you have the bulk of the pattern drawn, you can build up your shapes and make straight edges.

STEP 5: Ease up on the pressure to make your lines appear paler. Select a specific part of the drawing as your starting point (I chose the top of the hat) and draw in the pattern. Start at the part of your subject that's closest to you so that the pattern appears biggest there. Then as you draw, make the next honeycomb appear smaller and smaller. That's another way to give your drawing a sense of dimension.

STEP 6: In order to make her hat look like real honeycomb, add drips of sweet honey. Draw the drips so that they look like they're pouring out of some of the holes. Use your eraser to rub out some of the drawing to make room for more honey.

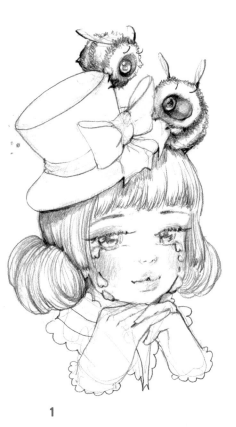

1

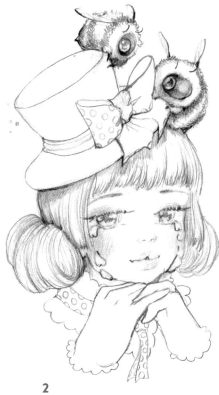

2

3

4

5

6

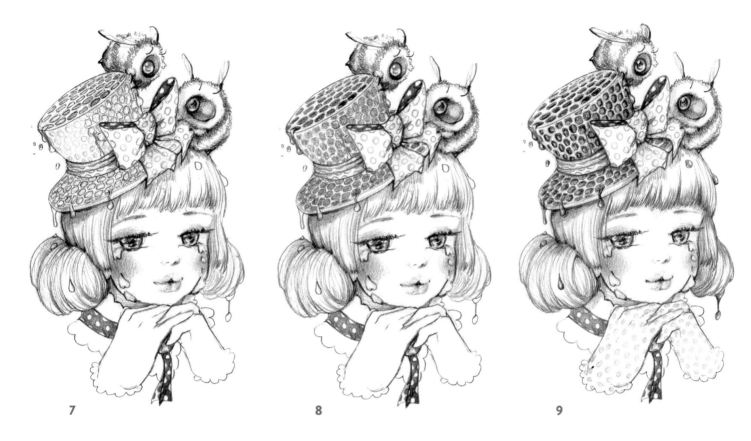

7

8

9

STEP 7: Now you're going to fill in your second pattern! Darken the pattern's edges. Try to keep the space between the holes consistent. At this stage, it's okay if you end up drawing over your initial pattern.

STEP 8: Add more detail to your honeycomb pattern! I like to darken the edges on three sides to add some dimension.

STEP 9: Add polka dots to her gloves! This step is similar to the first part of the pattern placement. The difference here is that you will need to use a hard 2H lead or soft pressure for placing this pattern. Start adding dots very lightly.

FINISHING UP: (Opposite page) Darken the dots and you're all done! Patterns are hard to draw, so make sure to take your time with them. Do lots of test drawings first. Once you master patterns, you can create some pretty incredible art!

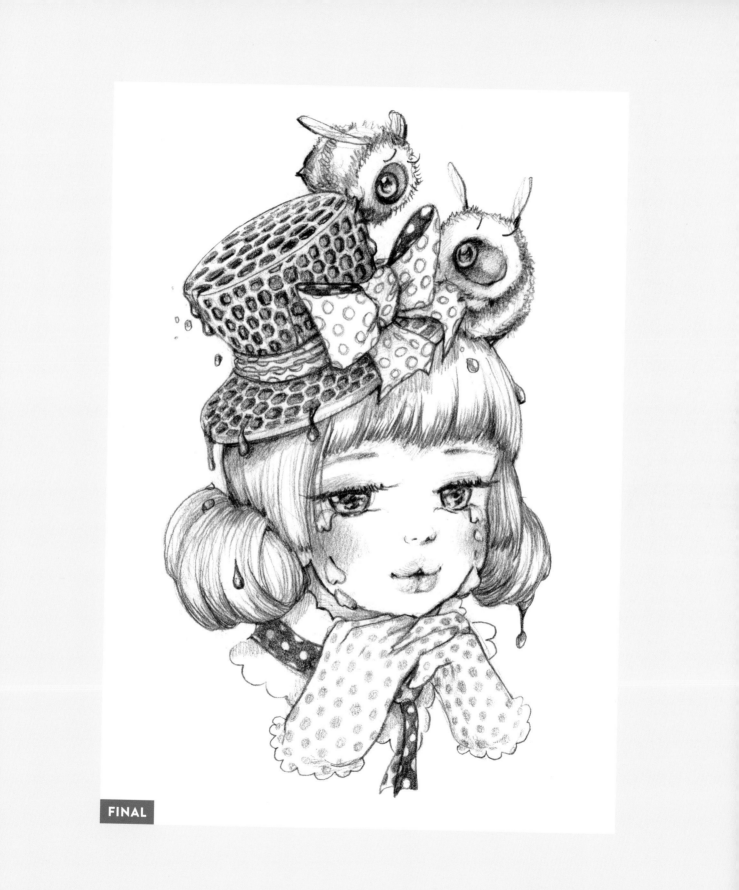

FINAL

Lovey Dovey

It's time to step things up! Now that you've gone through the lessons and drawn many characters, it's time to draw two characters interacting! Gird your loins and strap in for some hard-hitting surrealism in this master class lesson. Let's draw a cute couple that by all intents and purposes shouldn't work, one is a wolf and one is a deer . . . oh my, oh my, how are these two going to overcome their differences? Well, love is love. That's how!

STEP 1: Drawing two characters interacting is difficult, so take your time. First, starting with an HB lead, sketch out the base of where they will sit. Then, draw the couple as one element and not as separate entities. You want to set up the overall space that the characters take up.

STEP 2: Focus on defining your characters with simple shapes. Start with the girl first, since she is in front of the boy.

STEP 3: Now establish the boy character behind her. Since a lot of the boy is covered up, you only need to focus on contouring him relative to the girl. To avoid a stiff pose, never use a straight line for the spine. Always curve it. Remember that boys tend to be larger than girls and draw them accordingly.

When drawing eyes, the pupil doesn't have to be one solid circle, but it does have to be placed in the center of the iris.

1

2

3

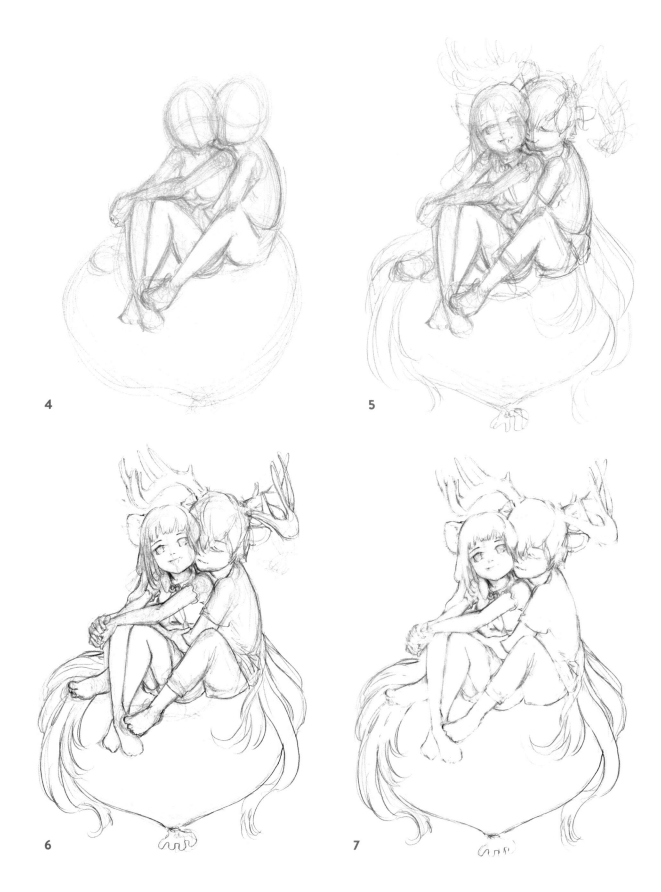

4

5

6

7

STEP 4: Things can get pretty crazy fast! Erase the parts of your characters that will be covered up. Strengthen the position of the boy parts visible over the girl's and vice versa. Then fill in some rough details on their faces, hair, and clothes.

STEP 5: Clean up your drawing and start adding more details to your characters. Be mindful of the parts of the girl's hair and ears that will cover the boy. Note how his hands and feet will cover her up as well.

STEP 6: Here is where your characters really begin to take shape. Finalize their features and their outfits. Erase excess lines to accommodate these new additions. It's important that you have the characters look separate yet interacting. It's a delicate balance.

STEP 7: Erase more lines. Take your time! One trick I've learned is to press the flat side of the eraser on the drawing and then gently, *so* gently, rub away the lines. Doing so takes off most of the underdrawing. It also removes some of your darker lines, but you can just redraw them.

Check out my anime eyes! Oh baby, am I not the cutest thing ever?

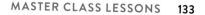

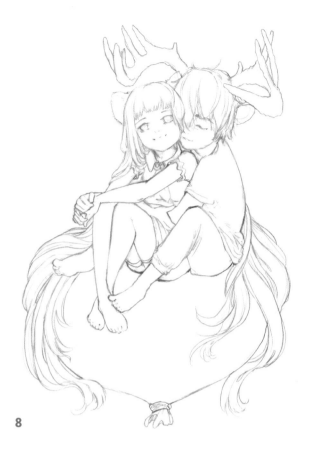

8

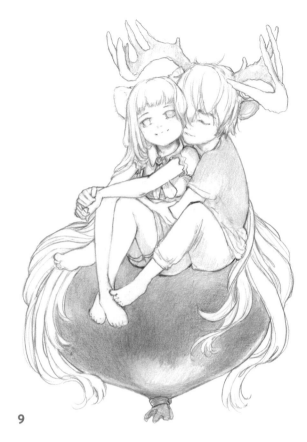

9

STEP 8: Switch to a darker lead like a 2B and make sure your pencil is sharp! Redefine your lines now. By this stage, you should be able to see some of the problematic areas that you'll want to erase and redraw. There are many curves and angles, so turn your paper to get the best position for your wrist for drawing the curves.

STEP 9: Have fun with shading! Fill in some of the areas that would have color, like the balloon. To shade in a balloon, make sure to include highlights and reflective light at the bottom. I used an eraser to remove the shading to establish beautiful points of light!

FINISHING UP: (Opposite page) Complete your drawing by adding in the little details to make it pop! I added some pattern to the balloon to give the scene some more lovey-dovey feelings. Make sure to shade the girl's hair. Keep the shadows to the undersides of her hair and leave parts white for highlights.

SIGN EVERYTHING

In the early days of my career, I didn't sign my art. Heck, I barely took pictures of it. Now I am diligent, like a mamma bear, when it comes to documenting my artwork. Sign your art every time. It doesn't have to be on the front, it can be on the back, but make sure you do, so that you have claim on it. Without your signature, anyone can claim it as theirs.

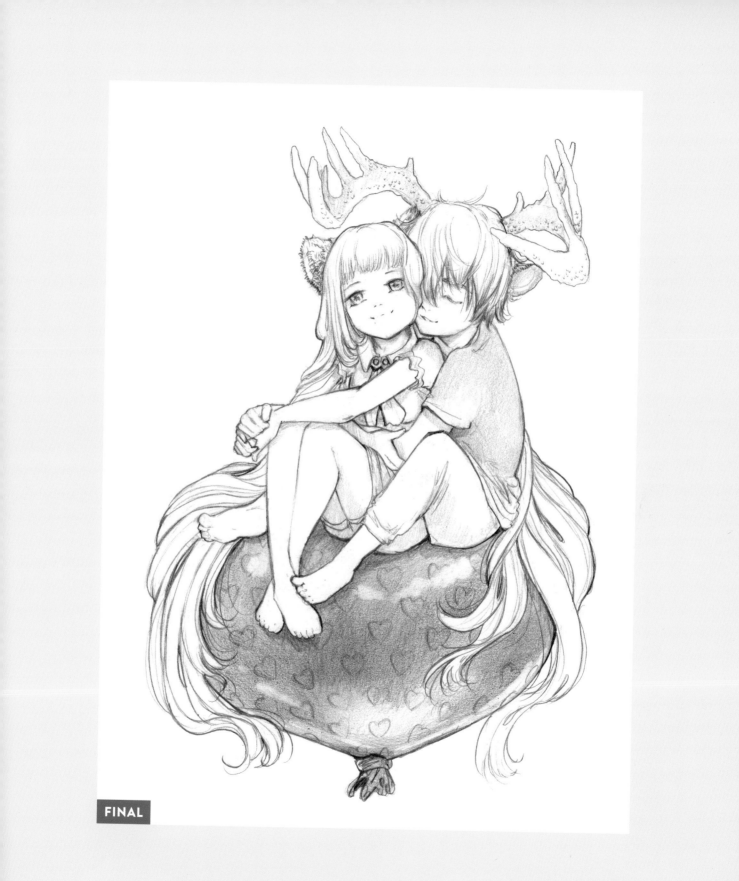

FINAL

Cuddles in a Cloud

I'm a hopeless romantic. That's one of the reasons I am so drawn to manga. It features so many love-centric stories that they'll keep the heart entertained for a lifetime. I'm going to mix the romantic manga style with the surreal part of myself that craves wild, bizarre imagery. So, let's show a cute couple holding hands on a swing suspended from a cloud.

Since Camilla doesn't have a photographic memory, she uses pics on her laptop for reference. I think that's just swell! Just don't copy the photo exactly, unless it's yours, okay? Don't be an art thief!

STEP 1: Using a midrange lead like an HB or a 0.5 mechanical pencil, draw the swing and the skeletons of your characters. Draw the swing first, as that sets the stage for our duo here. Sometimes you work the scene around the character, and other times, you fit your characters into the scene.

STEP 2: Because of the angles, this piece can be considered somewhat tricky to draw. You won't see the characters' waists and you will need to exaggerate the length of their legs, since the angle here has the viewer looking up at them. Lightly pencil in the body shapes, focusing specifically on the limbs.

STEP 3: Use a light pencil such as HB or 2H to add details to your characters. This step is all about their clothing and expressions. Bunch up the girl's clothing around her knees. You can even cover up the girl's knees if you like—it depends on how long you want the dress to be.

1

2

3

4

5

6

7

STEP 4: Spend time outlining your drawing with a darker 3B pencil. Draw carefully when intertwining the fingers. Add more wrinkles and details to the outfit as well—but not too many, since the next stage involves erasing!

STEP 5: Erase your underdrawing. Carefully switch between wider erasers for the larger areas and the mechanical eraser for the narrower parts. Hold the paper steady so that it doesn't accidentally wrinkle.

STEP 6: Retrace the drawing with a very sharp pencil. I recommend either a B or 2B graphite pencil or a 0.5 or 0.7 mm mechanical pencil for this stage. Try to contour with continuous strokes versus using lots of little, quick ones. You want a strong, confident outline. Use a ruler to draw the bench and rope!

STEP 7: Shade the characters. You can select how dark or how light to shade by the amount of layers you use, not by the darkness of your lead. If you want to have solid black areas, then definitely use a 4B or 5B pencil. However, I find the best way to achieve smooth shading is by building up the layers with H, F, or HB pencils.

Remember: When using pencils to draw, make sure to add pressure to achieve darker lines and lighten pressure if you want lighter marks.

8

9

STEP 8: For this step, let's focus on textures. Erase the edges of the cloud slightly, and then shade in the outline instead of using a solid line. Doing so will make the cloud look fluffy and will provide a great contrast to the characters. Use multiple lines for the wood texture.

STEP 9: Have fun adding in little details! Add patterns to their clothes at this stage for some fun lightning elements! Keep in mind the shape of the clothing and try to conform the pattern shapes to it.

FINISHING UP: (Opposite page) Clean up and touch up! Spend time finishing the wood details and darkening the lines. Remember to start at the edge of the character and move away with your pencil. Then erase and redraw the face if needed and again shade in the drawing to give it more dimensionality.

Let your art guide you! Sometimes the concept in your mind doesn't work as an actual drawing. Switch gears and let the art flow freely. Change your concept halfway or near the end. Either way is totally fine!

FINAL

The Griffin Games

Let's take things up a notch! So far, you've drawn many kinds of hair and many kinds of critters. So, let's make a drawing that pushes you creatively on these fronts. Let's draw a girl with curly hair and a baby griffin. And let's throw in some butterflies with surreal patterns on their wings! Oh yeah, baby, it's gonna get crazy.

Give your baby animals huge eyes. The bigger, the cuter! Think Puss 'n' Boots from *Shrek*!

STEP 1: Starting with an H or HB pencil, draw your circle and include crosshairs to indicate the girl's features. Draw a hand. I always imagine the hand as a series of shapes. Use circles for joints and rectangles for bones. For the underdrawing of the griffin, think of it as shapes—one for the head and one for the body.

STEP 2: Griffins are part eagle and part lion. To draw this unique creature, use several shapes, including several angular, oval, and circular ones, to create its face. You also want to add an expression for your character and include butterflies. I always use reference so that I can get the anatomy of my subjects right. Start with the girl's head and work around that.

STEP 3: When drawing curly hair, spiral it together, like you're drawing curly fries! Start at the top, and then swirl your line down. When you've established one line, add a second, and so on. Work from a wider space up top to a point at the bottom.

STEP 4: Add details—the feather and the fur—to the griffin. I like to use ruffled edges for the feathers. Add more jagged lines for its fur.

STEP 5: Erase some of your underdrawing so you can see what to outline. Spiral hair twirls together, so you have to fold it around itself. Doing this adds a lot of dimension to your piece.

STEP 6: Remove all of your underdrawing. Don't worry about erasing too much. You can redraw any essential part that you accidentally remove. Remember to hold down your paper with one hand while you erase with the other.

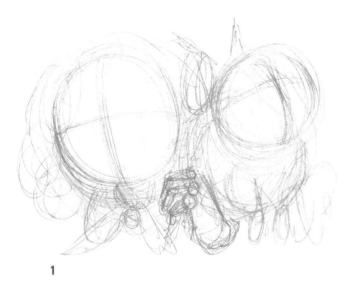

1

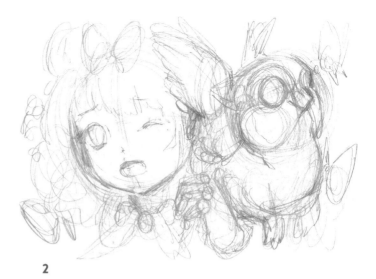

2

3

4

5

6

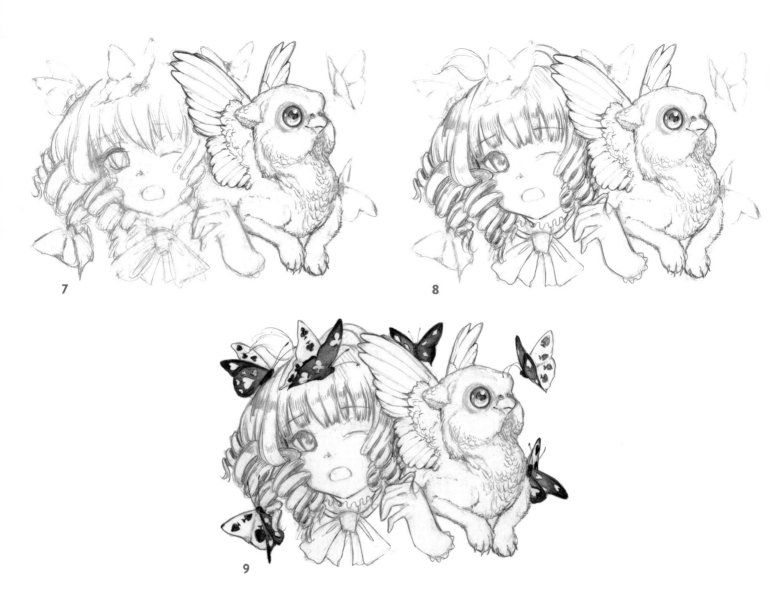

7

8

9

STEP 7: When drawing feathers, you want to go from top to bottom. You don't have to draw every single feather. I like to cluster them in certain areas and then leave other parts blank. Doing so creates balance in your drawing. Do make sure to draw the large flying feathers. Remember that too much detail can be overwhelming.

STEP 8: Let's focus on the girl and her curly hair! Contour the hair, but also add in lots more lines to darken the inside coils. It's important to show the inside of the curl for dimension. Make the inside darker than the outside.

STEP 9: Go to town on the butterflies! I added a bit more surrealism here by giving each of the butterflies a card symbol! Nothing says "I'm not in Kansas anymore" than butterflies made from playing cards. Use firm pressure and add a solid outline to each butterfly. Then gradually draw the symbols and fill them in with a dark 3B pencil.

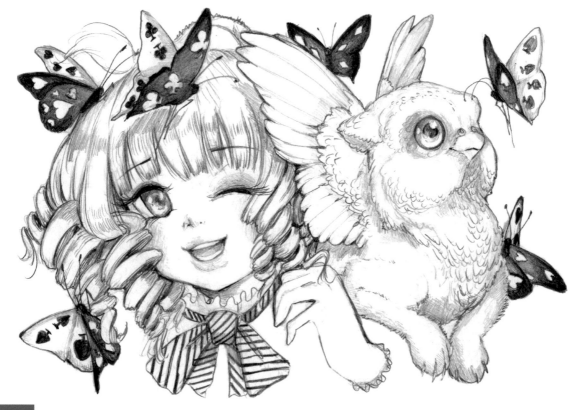

FINAL

FINISHING UP: Shade in your characters and define the details. You'll notice that I decided to change her expression at the very end! That's the beauty of pencil drawing. You can erase and redraw at any point! Try crosshatching certain areas for texture.

Dances with Dragons

Let's have some fun and create a scene where a playful girl interacts with a dragon and her babies. The surreal twist here is that the babies will have emerged from eggs filled with rainbows! I'm best known for my melting rainbow art, so we'll include that element in this master class lesson! Get ready, because this is going to be a longer lesson since it's more involved and detailed.

STEP 1: Use a 0.5 mechanical pencil or an HB lead to start this drawing. When creating a scene, be mindful of the space that your characters take up and consider how they interact with each other. Draw the dragon first. Start with a snake shape and add elements like feet and dragonlike embellishments. Since the dragon will take up more room than the girl, it's important to establish this element first!

STEP 2: Add your female character and the dragon babies. No matter what pose your character is in, always start with the head. You want your character to be fluid and not stiff, so draw the spine curved. Then jut out the limbs energetically.

STEP 3: The pose I want you to try for the girl can be tricky. There are lots of moving parts. Focus on how the limbs are connected to her body and make sure that your anatomy is correct. Draw the body in two parts, the top and the bottom. If you divide it from waist down to waist up, that will help with the anatomy.

STEP 4: When drawing the dragon, start at the head. Then, draw the top of the dragon's body and add fur. Doing so will help you define the top part and the underside (that has no hair).

The darker your shadow, the closer an object is to another.

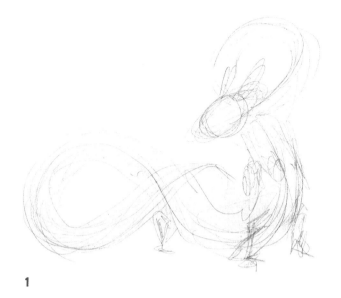

1

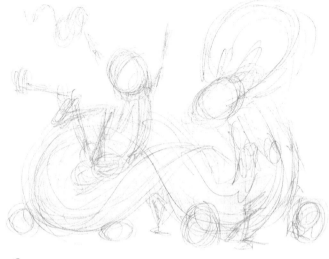

2

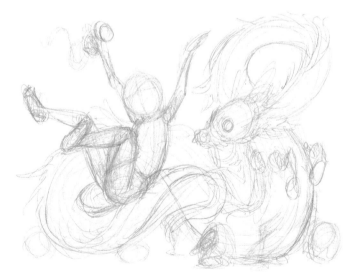

3

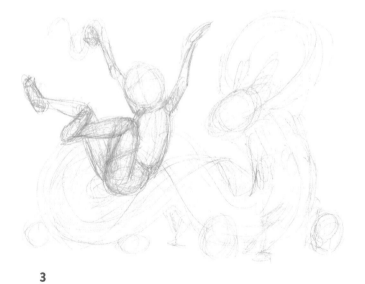

4

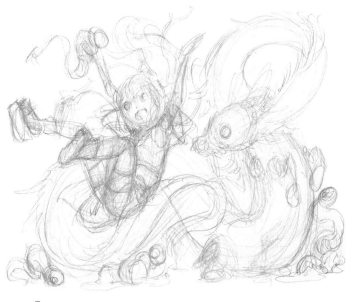

5

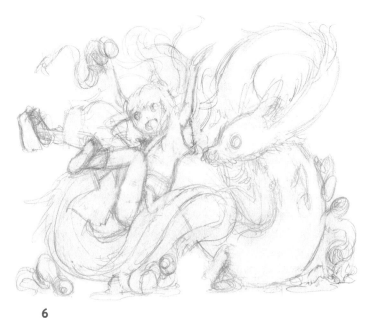

6

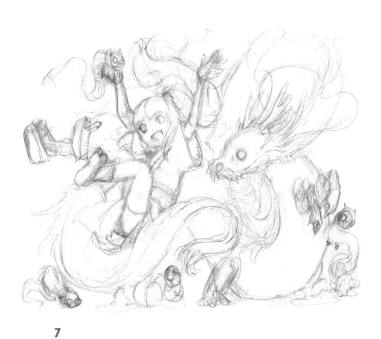

7

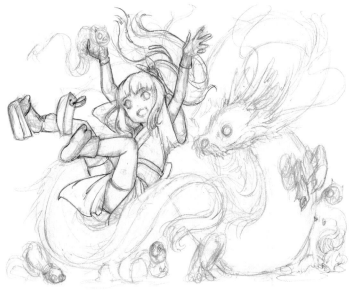

8

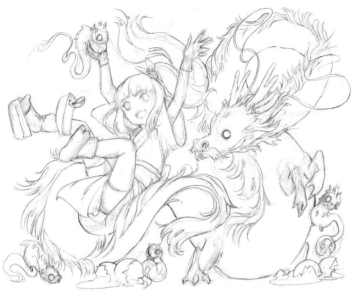

9

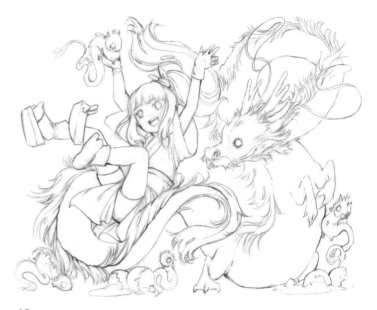

10

STEP 5: Using an F or HB pencil, lightly sketch the girl's features. Keep the overall details minimal and focus on the movement of her clothing and hair. This stage is the messiest one. There are a lot of layers, but try not to get overwhelmed. You'll clean everything up with the next step.

STEP 6: Let's clean this drawing up a tad! Before you add any more details, you'll want to erase certain areas to make room for the additional layering of elements. Due to how complicated this drawing is, you need to focus. Clearing the path is the best way to see ahead.

STEP 7: Once your drawing is clear of a lot of the underdrawing, you can refine the characters. Take it one element at a time. I always start from the head and work out from there. The head's the focal point of your character, so make sure the rest of the drawing revolves around it.

STEP 8: Now, it's time to outline! Switch to a darker 4B lead. Start with the girl. Outline her in full, focusing on adding swirls of hair, as well as drawing in her fingers. Try not to press too hard, in case you have to redraw. Remember to switch between your different soft and hard leads to achieve darker and lighter lines rather than simply relying on the amount of pressure you apply.

STEP 9: Let's outline your dragon using the 4B lead or a 0.7 mechanical pencil. Since the dragon has so much fur, start at its head. Draw the beginning of the hair and then layer from there. Swirl your pencil confidently. Try to use continuous strokes. Don't make small lines, since you still have to erase the underdrawing.

STEP 10: Erase the underdrawing and redefine the lines. Lay your eraser on the drawing gently and move it back and forth lightly. Doing so removes all of the underdrawing (as well as some of the outline, but just trace over what is erased). Focus on thickening the lines at the roots of the hair and on the undersides of the characters.

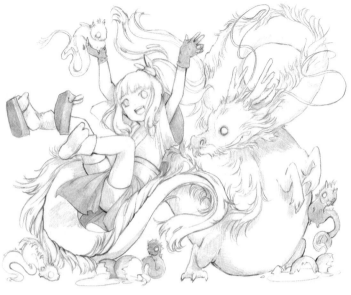

11

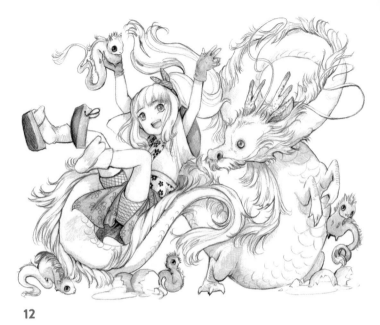

12

STEP 11: Using a light lead (such as an F, H, or HB), shade your drawing by turning your pencil almost flat to the paper and gently holding it near the eraser. Turn the paper around and repeat so that you shade the same area but from a different angle.

STEP 12: With this step, you want to add shadows over the top of your shading. Switch to a softer 3B lead for the shadows. The darker lead will make it easier for the shadows to pop! Now you can add the final details to your drawing using a 4B lead or 0.7 mechanical pencil. Dragon scales and the fine lines on the girl's hair and the dragon's fur, all of these add texture.

FINISHING UP: (Opposite page) The final step! You made it! You can use markers or pencil crayons for this step. Add the melting colors one at a time. Make one swirl of orange in one egg, and then do the same in the other. Think of it like ice cream melting. Pool the colors. Repeat the process with each color until you have created a melted rainbow.

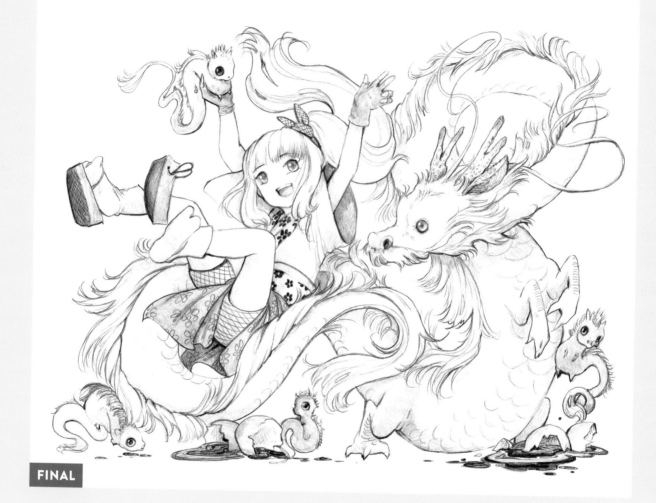

FINAL

That's a Wrap!

The end has come. But instead of feeling sad, I'm excited for everyone. I've given you all my knowledge from the many years of my artistic career. Now you get to have fun with it! Creating art is an absolute joy, and it should be fun whether it is for fun or as a career.

I wanted to become a working artist WAY back when I first saw *The Little Mermaid*, when I was a small child. I knew deep in my bones that I wanted to become an animator for Disney, and do art all day, and forever! Sadly, I'm not a very good animator, but that didn't stop me. I changed my direction and became a manga artist and painter. Life's funny that way. As a career artist, there is a lot of pressure to create art on demand. You must meet your deadlines, listen to editors or clients, change the art when it must fit the creative agenda, work day and night, and

deal with rejection, but above all, you must maintain your artistic integrity. It isn't easy, but it is rewarding. Spending all day making art is a privilege, and I work hard to maintain my career. I'm not sure that I chose to become a professional artist, or if art chose me. So whether you take what I've taught you in this book and apply it to your hobbyist art or take the plunge and become a professional artist I say, GOOD LUCK and may the art be with you!

Art is meant to be fun, whether you do it professionally like me or as a hobby as many others do. Just remember to create art in your own style. From here, you must take what you've learned and apply it to your own creative journey. Bring forth the best of yourself with your own art. Enjoy, my lovelies!

Goodbye cuties! Have fun creating lots of art!

Index

Dedicated to Thor the God of Thunder, you know why.

Special thanks to Tasha Zimich for helping me
power through the book and keeping my grammar
on the right track!

All rights reserved.
Published in the United States by Watson-Guptill
Publications, an imprint of the Crown Publishing
Group, a division of Penguin Random House LLC,
New York.
www.crownpublishing.com
www.watsonguptill.com

WATSON-GUPTILL and the HORSE HEAD colophon
are registered trademarks of Penguin Random House LLC.

Library of Congress Cataloging-in-Publication Data
 Names: D'Errico, Camilla, author.
Title: Pop Manga Drawing : 30 Step-by-Step Lessons
 for Pencil Drawing in the Pop Surrealism Style /
 Camilla d'Errico.
Description: First edition. | California : Watson-Guptill
 Publications, [2019] | Includes index.
Identifiers: LCCN 2018051244
Subjects: LCSH: Comic books, strips, etc—Japan—
 Technique. | Cartooning—Technique.
Classification: LCC NC1764.5.J3 D474 2019 |
 DDC 741.5/952—dc23 LC record available at
 https://lccn.loc.gov/2018051244

Trade Paperback ISBN: 978-0-399-58150-2
eBook ISBN: 978-0-399-58151-9

Printed in China

Design by Chloe Rawlins
Cover color by Karina Siu

10 9 8 7 6 5 4 3 2 1

First Edition

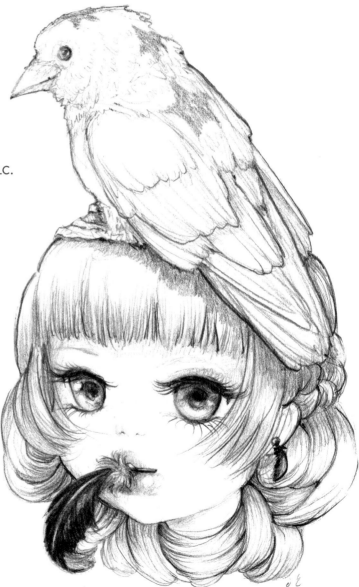